ZIPPY

Stories

by Bill Griffith

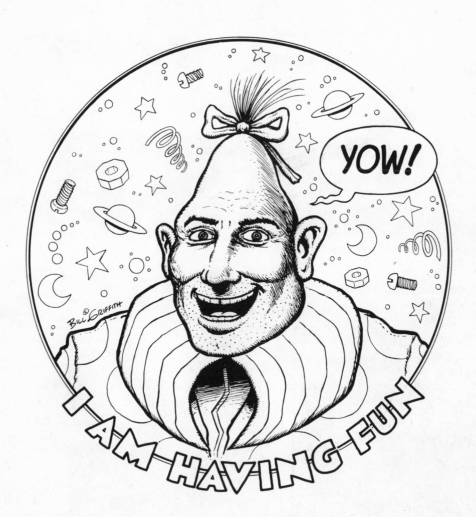

LAST GASP, INC.

San Francisco, California

Dedicated to my father James L. Griffith
who, at the dinner table, would occasionally
announce that I was a pinhead.

Copyright © 1974,1975,1976,1977,1978,1979,1980,1981,1984,1986

Published and Distributed by **Last Gasp, Inc.**
2180 Bryant St.
San Francisco, CA 94110

ISBN: 0-86719-325-5

Library of Congress Cataloging in Publication Data

Griffith, Bill, 1944–
 ZIPPY stories

 I. Title.
PN6728.Z52G7 741.5 '973 81-12809
 AACR2

Negatives and Camera Work: G. Howard, Inc., S.F. CA
Typesetting: Good Times Graphics, S.F. CA and Ampersand Design, S.F. CA

For information regarding newspaper syndication
write: Zipsynd, P.O. Box 40474, S.F. CA 94140

BOMC offers recordings and compact discs, cassettes
and records. For information and catalog write to
BOMR, Camp Hill, PA 17012.

CONTENTS

INTRODUCTION

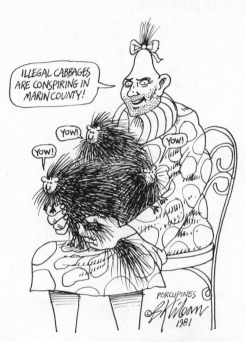

ILLEGAL CABBAGES ARE CONSPIRING IN MARIN COUNTY!

YOW!

YOW!

YOW!

PORCUPINES
©BKliban
1981

We all know what twisted deviates cartoonists are, and how warped their motives. Possibly the fact that Bill Griffith stands barely over three feet tall in high heels has compelled him to create a character as large and expansive as Zippy, but that's for the shrinks to figure out.

To tell the truth, I am not fond of Zippy's looks, though he dresses nicely, and wouldn't care to sit next to him in a diner or public conveyance, but to put it simply, the spirit of Zippiness makes me feel good.

Consider for instance, how much nicer it would be to have instead of the dreaded Claus, who always knows if we've been bad or good, a Christmas Zippy who couldn't care less what we've been. Interesting... nine pounds of squid under the tree...some plutonium earrings for mom or dad.

Another thing I like about Zippy is that although he is definitely not done for idiots, I have actually seen many idiots enjoying him on some level. This is gratifying to one involved in communication.

The last things I like about Zippy are the way semantic pies splatter on the walls of reason, philosophical spring sausages leap out of improbable containers, and rubber hatchets chop at the very foundations of our existence. Am I finished yet?

B. Kliban, April 1981

AN INTERVIEW WITH BILL GRIFFITH

Not an easy man to pin down, we caught up with Bill Griffith one afternoon in a frayed but respectable bar (glass brick front, dim lighting) in San Francisco's fog-shrouded Sunset district, an anonymous neighborhood of one-story, stucco houses. Seated in a booth away from the juke box and nursing a dry martini, he greeted us with a tentative smile.

Q. So you're the man behind the Pinhead.

A. Yep, I'm the perpetrator.

Q. I have to admit I was half expecting a hyperactive maniac in a polka-dotted clown suit.

A. You wanta see the suit? I've got it in the car..

Q. Uh, no, that's all right..I..

A. Really, it's no trouble, I've even got the shoes and...

Q. No, no, I was just kidding...ha ha... Can we get on with the interview?

A. You buying?

Q. Uh, sure...Now, let's see..When and where did Zippy first appear? How did it all begin?

A. Bartender, another martini, two olives.. Well,...You sure you don't want to see the costume? No, I guess not..Okay, where did it all start?..It was back in 1970. I did a strip for "Real Pulp" comics titled "I Gave My Heart To A Pinhead And He Made A Fool Out Of Me!". I called him "Danny" for no apparent reason. I thought it would just be a one-shot thing. Little did I know.

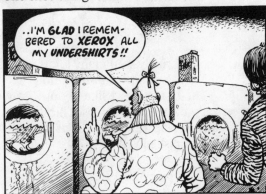

Q. How did you come up with the idea? What's behind it all?

A. Somewhere in downtown Duluth, Anita Ekberg is marinating a digital watch.

Q. Uh, right...I see...

A. Zippy is a super-hero without muscles. He doesn't know about "shared reality", he has a date with Henry Kissinger.

Q. Frankly, he sounds like a classic schizophrenic personality.

A. Yes, he's completely in tune with the times.

Q. Let's get a little background on you, if that's okay...

A. Well, I wasn't always the way you see me now. For a few years back in the sixties, I thought I was an "artiste". Inside, though, there was a comedian trying to get out. I made the transition from painting to comics quickly, although it did take me years to learn the "language". My first character was Mr. ("The") Toad, a rather mean-spirited amphibian dressed in a tight-fitting tweed suit. Actually, I created Zippy, after the initial "Danny" episode, as a sidekick for Mr. Toad. I thought he would kind of soften, or, at least exasperate Toad's bad-boy nature. Instead, he took over.

Q. For a number of years your work appeared mostly in "Underground Comics" ..but that's not the case as much these days.

A. Well, I still enjoy the freedom of the comic-book form, but I also like to see Zippy infect the world at large. Magazines, newspapers, paperbacks, coffee mugs..

Q. Where else can readers see new Zippy strips?

A. Right now you can find him in a couple of national magazines and in newspaper syndication. The strip's also in a few college papers.

Q. Where did the name "Zippy" come from? Did you know there's a chain of fast food restaurants in Hawaii called "Zippy's"?

A. My lawyers are working on it..Actually, the name is derived from "Zip the What-Is-It", a real pinhead exhibited for many years by the Barnum and Bailey Circus. His real name, by the way, was William H. Jackson, the *same* as *my* great-grandfather. And, since my full name is William H. Jackson Griffith,

it's all the more unnerving.

Q. You're serious?

A. Does Hostess make Twinkies?

Q. How do you account for Zippy's rising popularity these days? Last Halloween there were two people dressed up as Zippy at a party I attended...

A. Maybe it's because everyone is so media-saturated...Possibly, Zippy provides a kind of release valve for all the pressure, all the information we're bombarded with every hour of the day. When Zippy spouts his non-stop non-sequiturs, *his* craziness makes the "real world" craziness more apparent. Or, maybe Zippy is a "role model for the future", as some article put it a while ago. That's an interesting thought—thousands of Zippys wandering around...Jeez, there'd soon be a shortage of Ding Dongs and taco sauce...

Q. Ding Dongs and taco sauce seem to be among Zippy's favorite foods—ever try the combination yourself?

A. No, but I do enjoy peanut butter and beets...which reminds me..Bartender? Another martini please...

Q. I understand Zippy ran for President in 1980. How did he do?

A. He won.

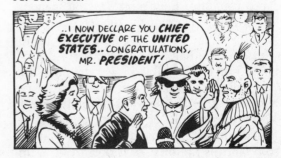

Q. Have you ever encountered people who just don't "get" Zippy? After all, he's not your typical cartoon character.

A. Yes, Zippy can be perplexing..He's consistently inconsistent and that can make for a little confusion at first. You kind of have to get on his wave length.

Q. How about your other characters..you've done a lot of things besides Zippy over the last ten or so years...

A. I guess my first "hit" in comics was "Young Lust", a parody of Romance comics ...you know, the kind teenage girls used to read. They're not published anymore, but "Young Lust" still goes on. Anyway, I created a modern, "swinging" couple called "Randy and Cherisse". They spent a lot of time in shopping malls and therapy. Then there are the Toadettes, who turn being naughty into a lifestyle..and Claude Funston, a kind of failed Gary Cooper, living in a Mobile Home Park..and a host of recycled, re-invented '50s T.V. personalities and historical figures I like to play around with. Then there's my "other side"—the "Griffith Observatory", a vehicle for my somewhat cranky, social-satire impulses.

Q. Television and film seem to have influenced your stuff quite a bit. Do you spend a lot of time in front of the tube?

A. I have the usual love-hate relationship with T.V. If I had a video recorder, I'd probably watch "Sgt. Bilko" re-runs until my eyes fell out...Like most Americans, I've absorbed the characters and plotlines of 10,000 sitcoms, B-Movies and talk shows. Doing comics gives me a way to re-channel some of this nuttiness so it doesn't back up on me like clogged plumbing.

Q. To get back to Zippy—he seems to pop up in various European publications now and then. Is he read much overseas?

A. I guess irrational behavior isn't only limited to America. Zippy is gaining a following in Germany and Spain and his ravings have been translated into Dutch, French and Japanese too. I wonder if I'll ever find out how you say "Yow! I am having fun!" in Swahili...

Q. Is Zippy *always* having fun?

A. Yes, even when he's depressed.

Q. What would you do if Zippy walked into this bar and sat at the next table?

A. I'd order him a Brandy Alexander.

Q. Does Zippy have a "message" for the world?

A. Sure. Zippy says, "If you want to be happy, just imagine you're playing Monopoly with Doris Day and Walter Cronkite. Suddenly, Frankie Avalon drops in with a can of Redi-Wip and two dozen issues of 'Modern Knitting'!!". □

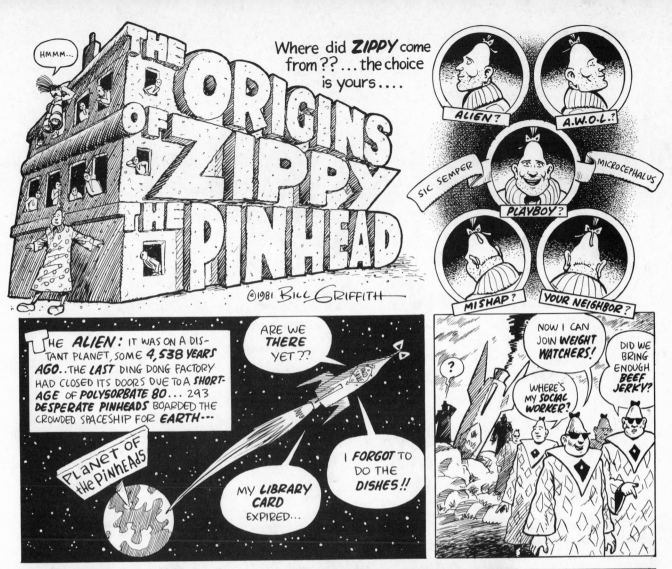

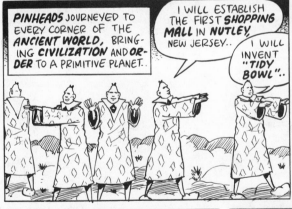

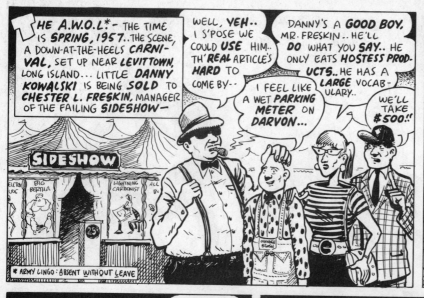

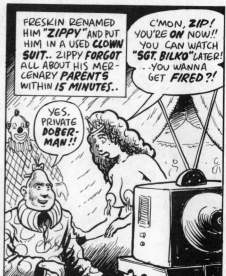

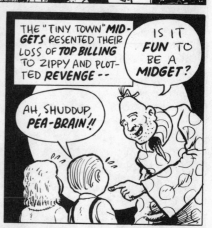

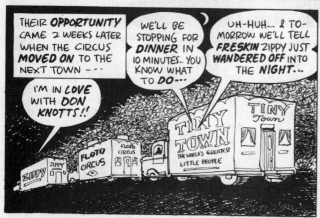

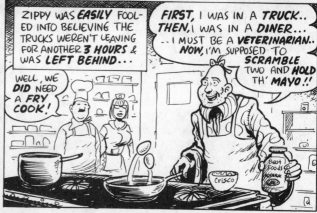

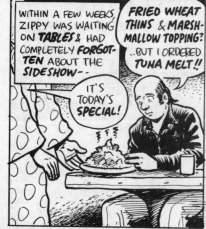

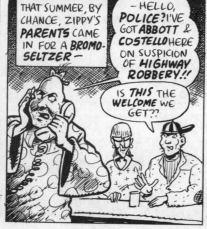

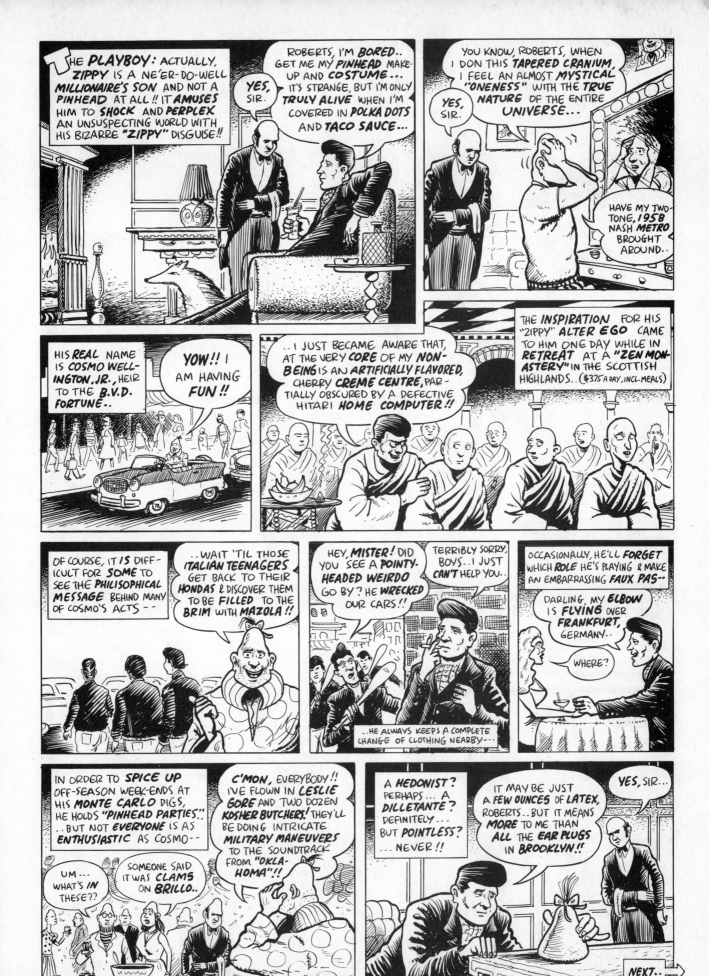

THE **MISHAP**: HIGH IN THE **PORTOLA VALLEY HILLS**, NEAR **PALO ALTO**, CALIFORNIA, THERE WAS ONCE AN EARLY **GENETIC ENGINEERING LABORATORY**.

I HAVE **DONE** IT!! I HAVE CRE-ATED **HUMAN LIFE** BY **ARTIFICIAL MEANS**!! THIS IS THE **HIGH POINT** OF MY ILLUS-TRIOUS **CAREER**!!

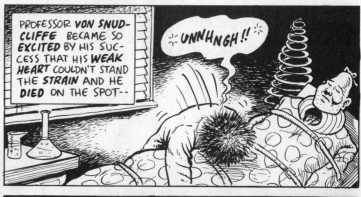

PROFESSOR **VON SNUD-CLIFFE** BECAME SO EXCITED BY HIS SUC-CESS THAT HIS **WEAK HEART** COULDN'T STAND THE **STRAIN** AND HE **DIED** ON THE SPOT---

UNNHNGH!!

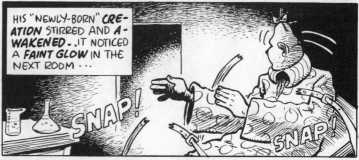

HIS "NEWLY-BORN" CRE-ATION STIRRED AND A-WAKENED.. IT NOTICED A **FAINT GLOW** IN THE NEXT ROOM---

SNAP!

SNAP!

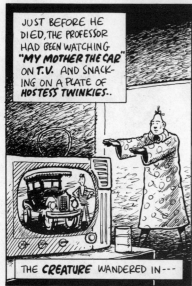

JUST BEFORE HE DIED, THE PROFESSOR HAD BEEN WATCHING "MY MOTHER THE CAR" ON T.V. AND SNACK-ING ON A PLATE OF **HOSTESS TWINKIES**..

THE **CREATURE** WANDERED IN---

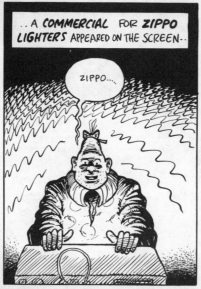

.. A **COMMERCIAL** FOR **ZIPPO LIGHTERS** APPEARED ON THE SCREEN..

ZIPPO....

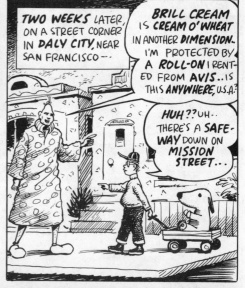

TWO WEEKS LATER, ON A STREET CORNER IN **DALY CITY**, NEAR SAN FRANCISCO---

BRILL CREAM IS **CREAM O' WHEAT** IN ANOTHER **DIMENSION**. I'M **PROTECTED** BY A **ROLL-ON** I RENT-ED FROM **AVIS**..IS THIS **ANYWHERE**, U.S.A.?

HUH?? UH.. THERE'S A **SAFE-WAY** DOWN ON **MISSION STREET**...

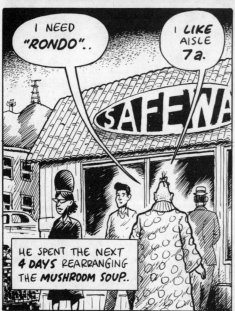

I NEED "RONDO"..

I **LIKE** AISLE 7a.

HE SPENT THE NEXT **4 DAYS** REARRANGING THE **MUSHROOM SOUP**..

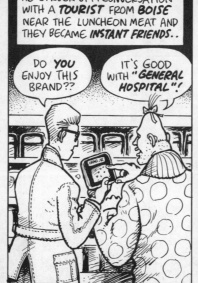

HE STRUCK UP A CONVERSATION WITH A **TOURIST** FROM **BOISE** NEAR THE LUNCHEON MEAT AND THEY BECAME **INSTANT FRIENDS**..

DO **YOU** ENJOY THIS BRAND??

IT'S GOOD WITH "**GENERAL HOSPITAL**"!

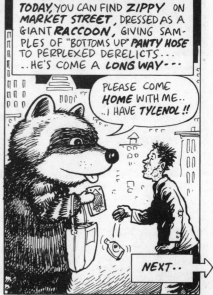

TODAY, YOU CAN FIND **ZIPPY** ON **MARKET STREET**, DRESSED AS A GIANT **RACCOON**, GIVING SAM-PLES OF "**BOTTOMS UP**" **PANTY HOSE** TO PERPLEXED DERELICTS... ..HE'S COME A **LONG WAY**---

PLEASE COME **HOME** WITH ME.. ..I HAVE **TYLENOL**!!

NEXT..

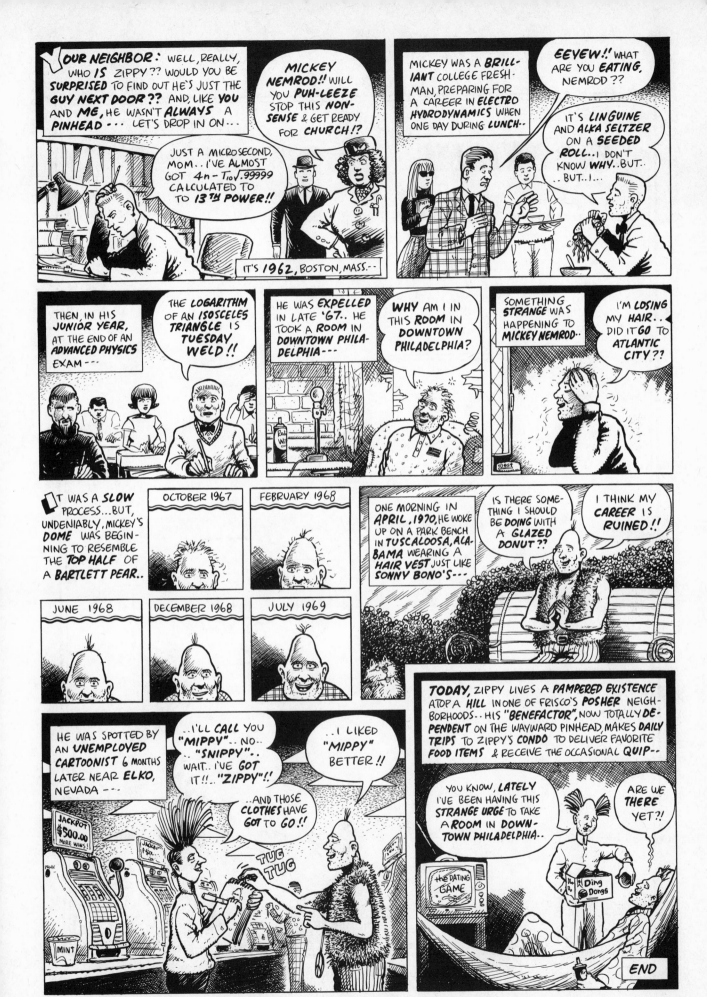

ZIPPYISMS

Zippy covers the entire kitchenette of his new condo with shiny Mylar. (The salesman down at K-Mart told him it was the "now" thing to do.) When the job is done, he realizes he can't find his "Roach Motel", so he breaks into a heartwarming rendition of "It's My Party And I'll Cry If I Want To".

Zippy's Day

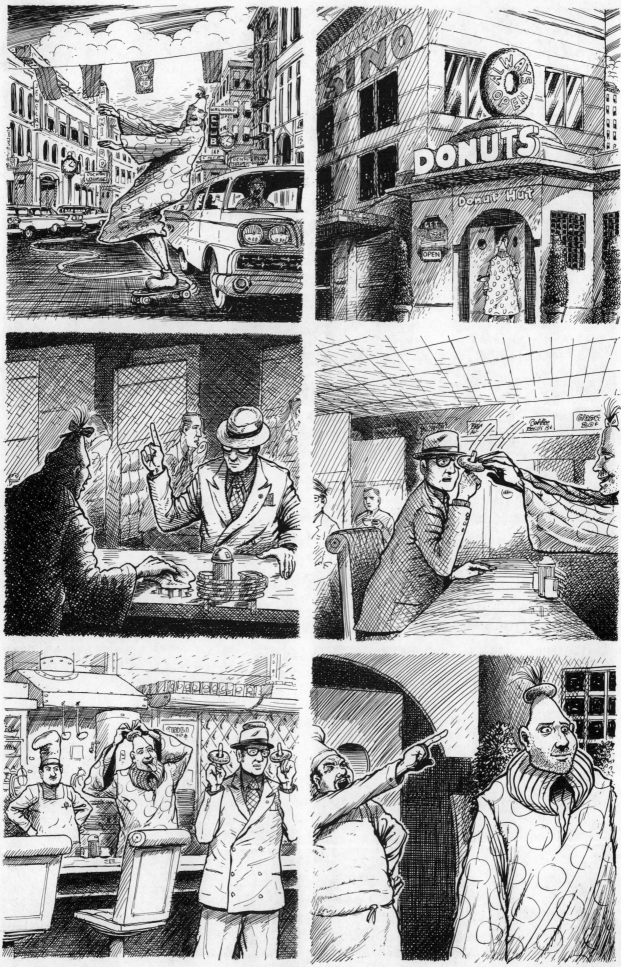

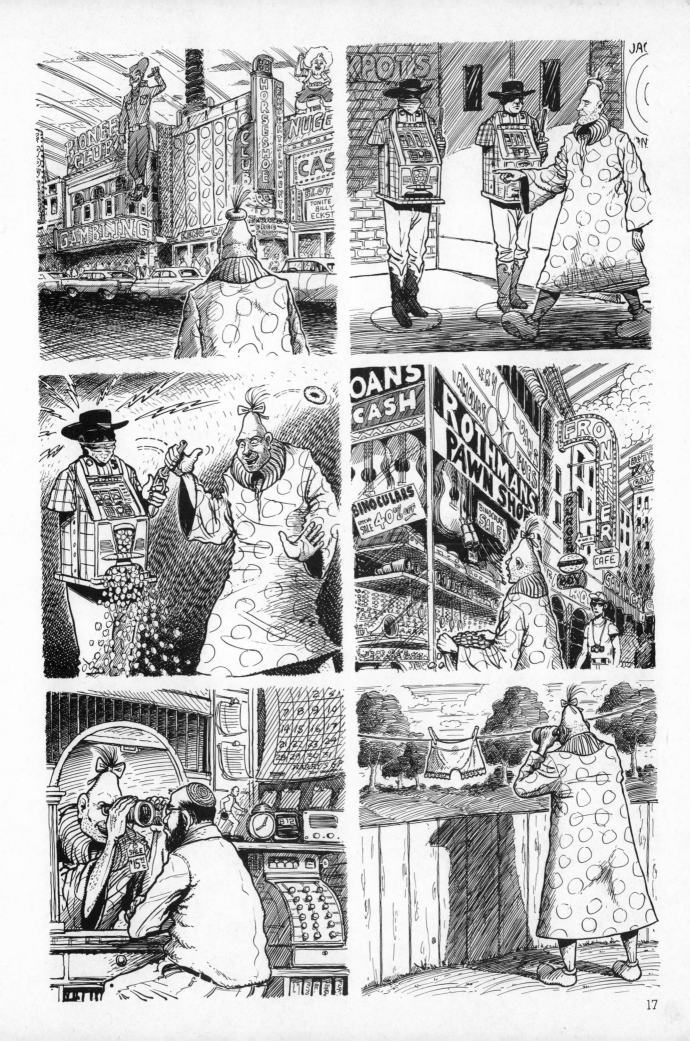

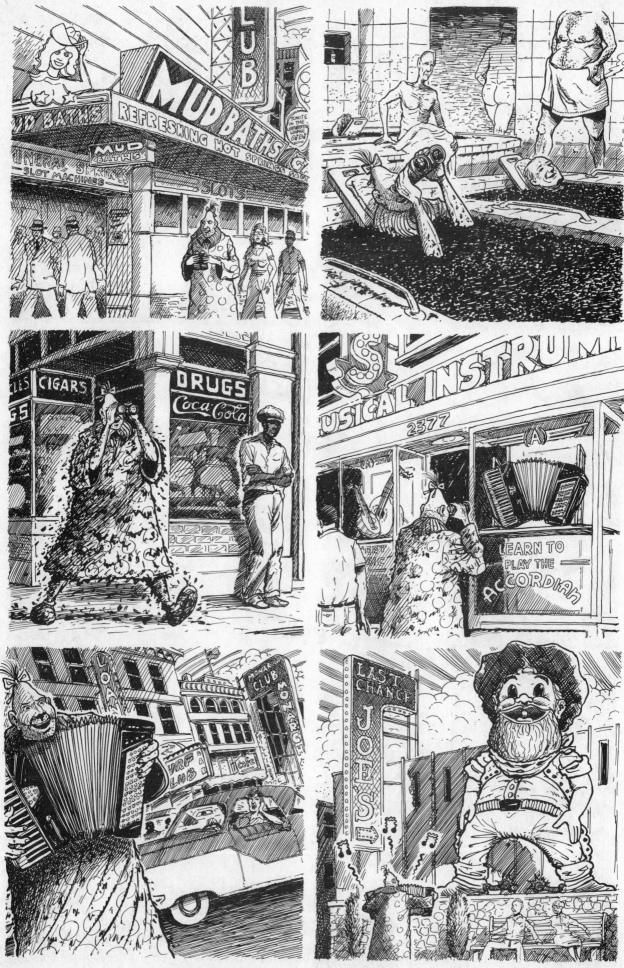

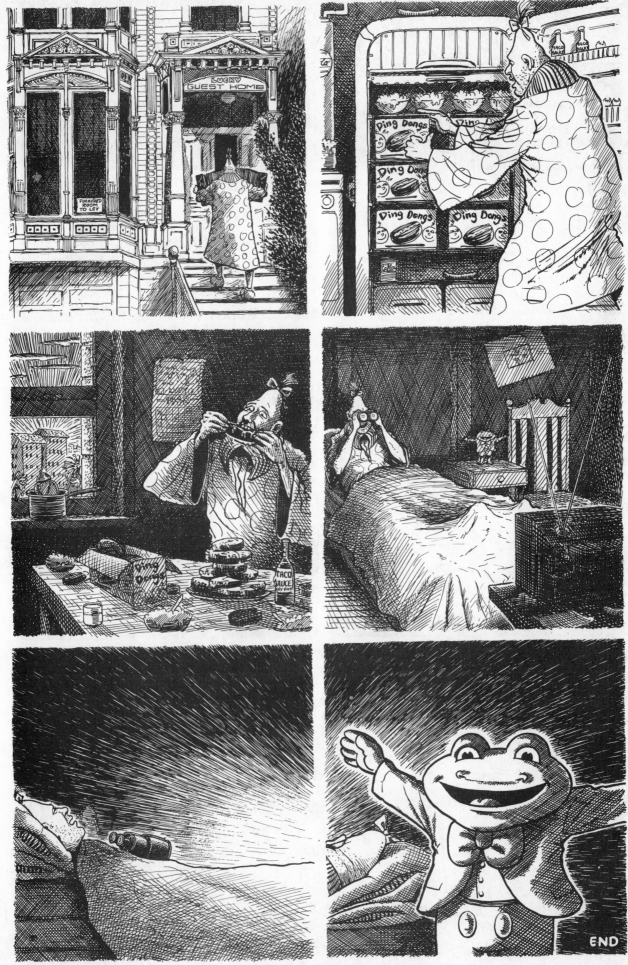

ZIPPY

ENGAGES IN SEXUAL ACTIVITY

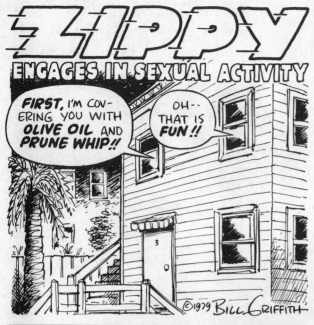

FIRST, I'M COVERING YOU WITH OLIVE OIL AND PRUNE WHIP!!

OH-- THAT IS FUN!!

©1979 BILL GRIFFITH

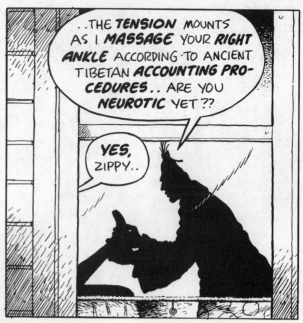

..THE TENSION MOUNTS AS I MASSAGE YOUR RIGHT ANKLE ACCORDING TO ANCIENT TIBETAN ACCOUNTING PROCEDURES.. ARE YOU NEUROTIC YET??

YES, ZIPPY..

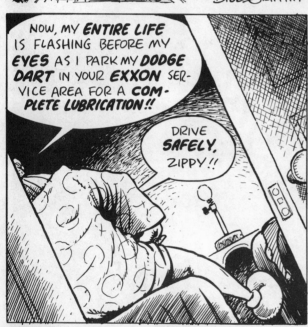

NOW, MY ENTIRE LIFE IS FLASHING BEFORE MY EYES AS I PARK MY DODGE DART IN YOUR EXXON SERVICE AREA FOR A COMPLETE LUBRICATION!!

DRIVE SAFELY, ZIPPY!!

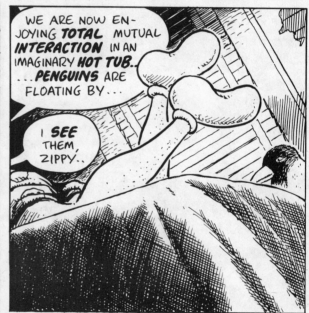

WE ARE NOW ENJOYING TOTAL MUTUAL INTERACTION IN AN IMAGINARY HOT TUB.. ..PENGUINS ARE FLOATING BY...

I SEE THEM, ZIPPY..

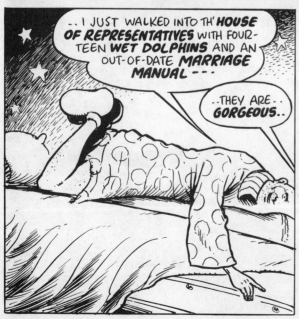

..I JUST WALKED INTO TH' HOUSE OF REPRESENTATIVES WITH FOURTEEN WET DOLPHINS AND AN OUT-OF-DATE MARRIAGE MANUAL ---

..THEY ARE.. GORGEOUS..

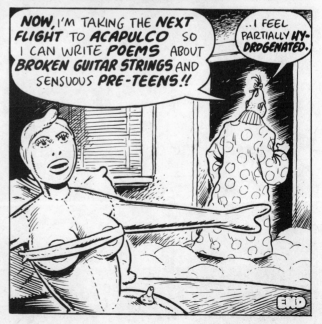

NOW, I'M TAKING THE NEXT FLIGHT TO ACAPULCO SO I CAN WRITE POEMS ABOUT BROKEN GUITAR STRINGS AND SENSUOUS PRE-TEENS!!

..I FEEL PARTIALLY HYDROGENATED.

END

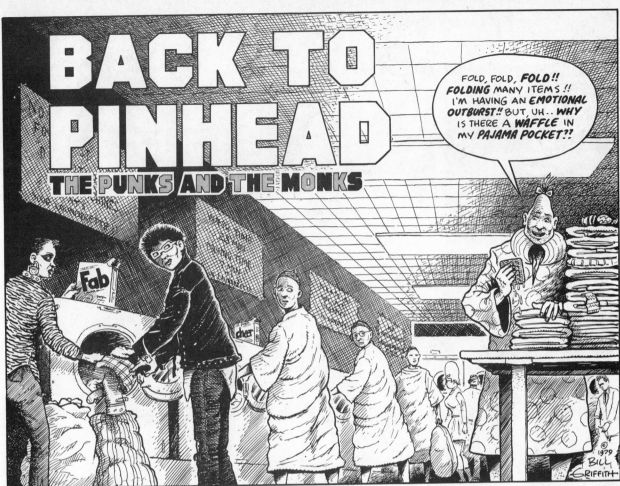

BACK TO PINHEAD
THE PUNKS AND THE MONKS

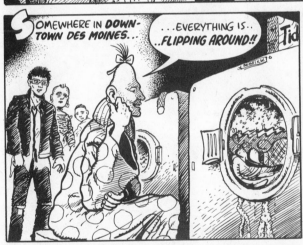

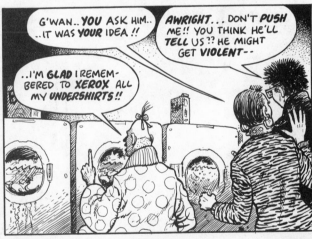

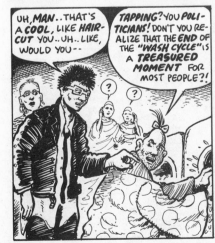

..WAS IT IN THIS PAPER...? YEH !! HERE IT IS !!

..WAY IN TH' BACK... A LITTLE ARTICLE..

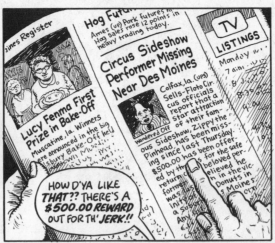

Hog Futures
Ames (up) Pork futures in Hog sales rose 12 points in heavy trading today.

Circus Sideshow Performer Missing Near Des Moines

Colfax, Ia. (UPS) Sells-Floto Circus officials report that a star attraction of their famous Sideshow, Zippy the Pinhead, has been missing since last Thursday. $500.00 has been offered by th... for the safe return of... their beloved per... believed... him in the vic... was... a Sub... Any...

Lucy Fenma First Prize in Bake-Off
Muscatine, Ia. Winners were announced in the big ...sbury Bake-Off held ...win Musc...

TV LISTINGS
Monday
7 a.m.
8
9

HOW D'YA LIKE THAT?? THERE'S A $500.00 REWARD OUT FOR TH' JERK!!

WOW!! 500 BUCKS!

SHIT! THOSE RELIGIOUS NUTS MIGHT BE ON TO IT!!

I HAVE A TINY BOWL IN MY HEAD!!

WHAT TH'...?

HUH?

COULD HE BE THE META-BEING SPOKEN OF IN THE TEACHINGS?

..OF COURSE, YOU UNDERSTAND ABOUT THE PLAIDS IN THE SPIN CYCLE--

YES..HE HAS COME AT LAST!

HE WAS DESCRIBED THUSLY!

SPEAK, O LORD! LIGHT THE PATH !!

HELLO, ZIPPY! ..UH...WHO'S YOUR FAVORITE GROUP??

MY FAVORITE GROUP IS "QUESTION MARK & THE MYSTERIANS"..

GET LOST, YOU SPAZ-DICKS! LEAVE MY FRIEND ALONE!!

OMM ..MMM ..MM

UNF!!

WELL, I GOT RID OF--BUH?

HEY, MAN !! YOU DON'T WANNA DO THAT!! WE'LL GO OVER TO MY PLACE... YOU LIKE PIGS KNUCKLES??

NO!! BUT THE MYSTERIANS ARE IN HERE WITH MY CORDUROY SOAP-DISH!!

HOLY FUCK!!

HE'S STUCK !!

I'M HAVING A BIG BANG THEORY!!

HE UTTERS THE PARADOXES WITH SUBTLE ALTERATIONS... AND HIS MANNER..IT CLEARLY ANNOUNCES HIS EXTRATERRESTRIAL ORIGIN!!

THE TEACHINGS MAKE OUR DUTY PLAIN.. HE MUST UNITE WITH OUR UNIT!!

LAUNDRY IS THE FIFTH DIMENSION!!

WE'LL JUST LET HIM STAY HERE 'TIL WE'RE READY TO GO..

YEH.. OH, CHRIST, WE'VE STILL GOT ALL THAT STUFF IN TH' DRYER..C'MON, HELP ME FOLD--

AWRIGHT.. LET'S GET IT OVER WITH!!

WE'LL BE BACK IN A SEC', UH, ZIPPY!!

...UM...UM... ..TH' WASHING MACHINE IS A BLACK HOLE AND THE PINK SOCKS ARE BUS DRIVERS WHO JUST FELL IN!! IT'S SO OBVIOUS !!

WISE ONE?? WOULD YOU CARE TO JOIN US AT THE "ALL-ONE HOUSE" FOR TEA AND PARSNIPS?

WE EAT ONLY PARSNIPS..

Later..

Soon...

23

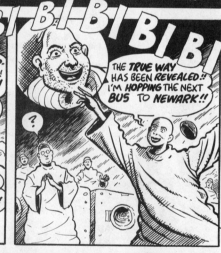

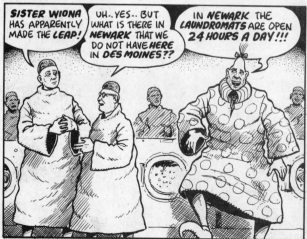

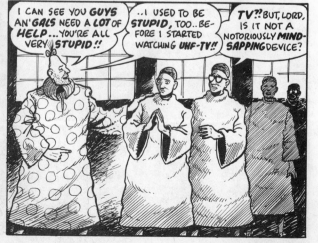

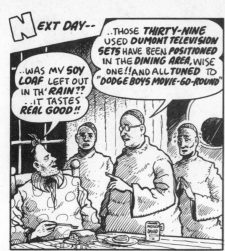

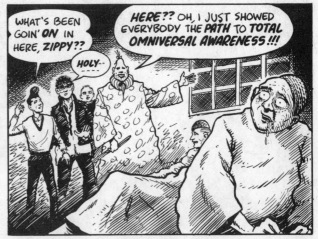

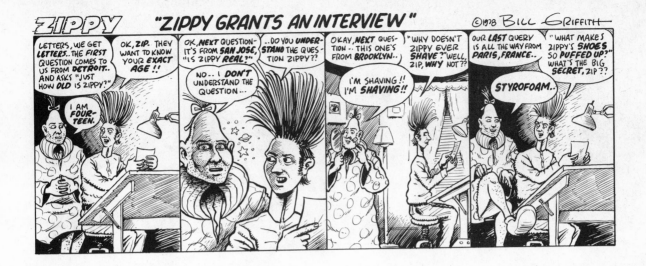

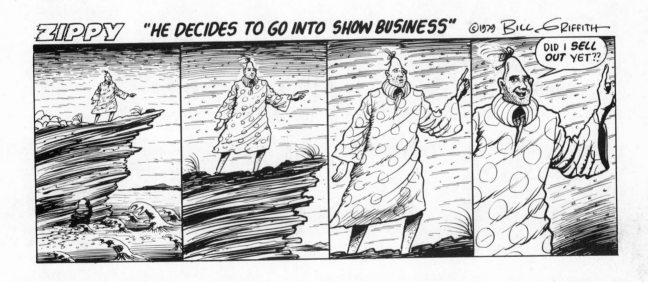

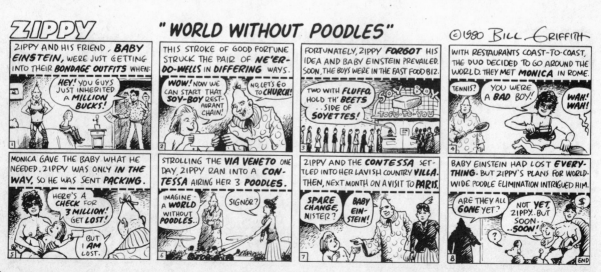

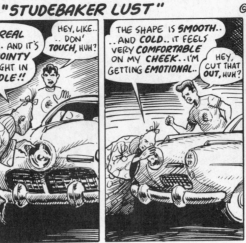

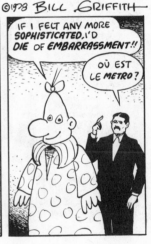

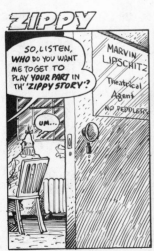
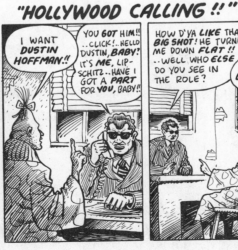
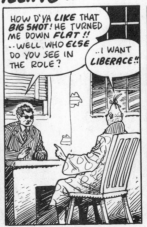

ZIPPY — "LIKE, YOW.." — ©1980 Bill Griffith

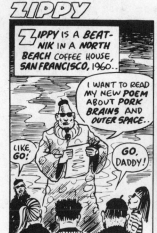

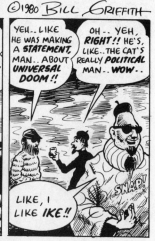

ZIPPY — "END OF AN ERROR" — ©1980 Bill Griffith

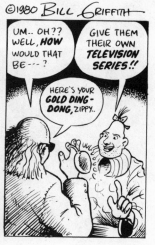

ZIPPY — "LIPPY DRIVES A BARGAIN" — ©1981 Bill Griffith

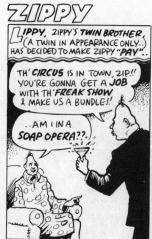
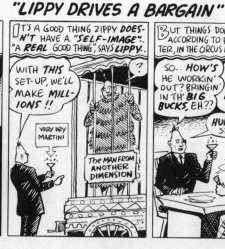
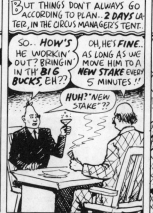

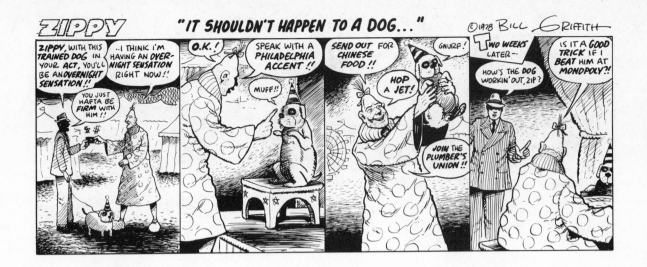

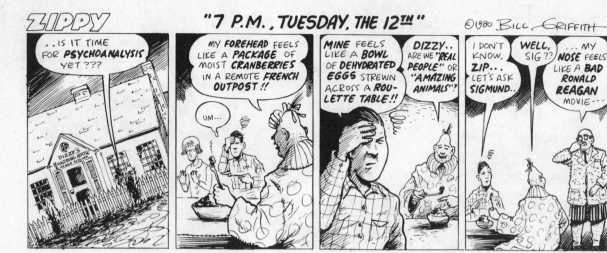

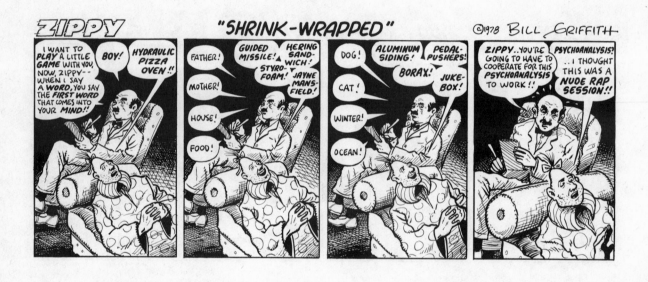

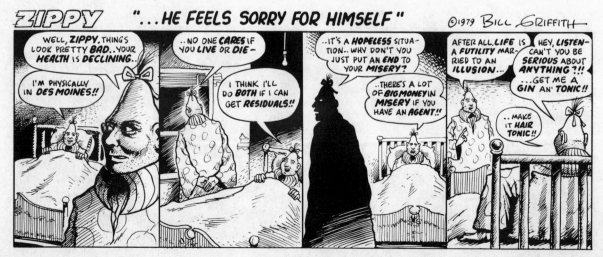

ZIPPY "ZIPCARDS: COLLECT 'EM ALL !!"
©1981 Bill Griffith

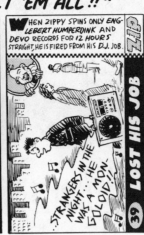
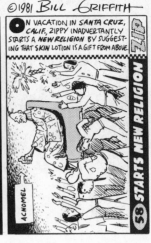

7 — HELD BY SPACEMEN: An alien space craft lands on Zippy's patio. He is taken to a drive-in movie where he falls asleep during 'Blood Beach'.

13 — OUT ON A DATE: Zippy tries to impress his teen-age date by spreading organic mayonnaise all over the hood of his Chevy Impala.

39 — LOST HIS JOB: When Zippy spins only Englebert Humperdink and Devo records for 12 hours straight, he is fired from his D.J. job.

58 — STARTS NEW RELIGION: On vacation in Santa Cruz, Calif., Zippy inadvertantly starts a new religion by suggesting that skin lotion is a gift from above.

ZIPPY ♫ "DO THE ZIPPY" ♫
©1981 Bill Griffith

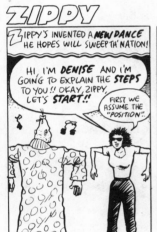
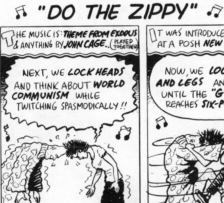

Zippy's invented a new dance he hopes will sweep th' nation! — HI, I'M DENISE AND I'M GOING TO EXPLAIN THE STEPS TO YOU!! OKAY, ZIPPY, LET'S START!! — FIRST WE ASSUME THE "POSITION".

The music is: theme from Exdous & anything by John Cage.. (played together) — NEXT, WE LOCK HEADS AND THINK ABOUT WORLD COMMUNISM WHILE TWITCHING SPASMODICALLY!!

It was introduced last month at a posh New York disco.. — NOW, WE LOCK ARMS AND LEGS AND SPIN UNTIL THE "G" FORCE REACHES SIX-POINT-ONE!!

Now you know how.. so get out there & do the Zippy!! — FINALLY, RESUME THE "POSITION" AND DISCUSS RISING REAL ESTATE VALUES!! — CHUBBY CHECKER OWNS MY BUILDING!!

ZIPPY "SPORTS SIMULATED"
©1981 Bill Griffith

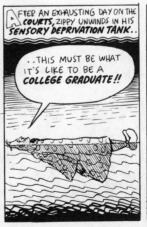
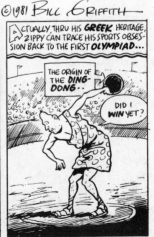

Like many of us, Zippy has become involved in a vigorous physical fitness program... — ...AM I JOGGING YET??

Tennis is a big favorite.. when Zippy wins a match, he pours waffle batter on his shoe. — I WORKED UP A BIG SWEAT, SO I REALLY DESERVE THIS!! — BUT, ZIPPY, YOU LOST!!

After an exhausting day on the courts, Zippy unwinds in his sensory deprivation tank.. — ..THIS MUST BE WHAT IT'S LIKE TO BE A COLLEGE GRADUATE!!

Actually, thru his Greek heritage, Zippy can trace his sports obsession back to the first Olympiad... — THE ORIGIN OF THE DING-DONG.. — DID I WIN YET?

ZIPPY — "DISMEMBERMENT OF THINGS PAST"

© 1981 Bill Griffith

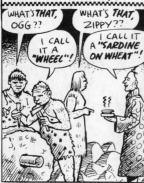

Panel 1: Zippy has been around for quite a while. In fact, he was present as early as 18,768 B.C.

What's *that*, OGG??

I call it a *"WHEEL"!*

What's *that*, ZIPPY??

I call it a *"SARDINE ON WHEAT"!*

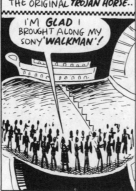

Panel 2: A few *MILLENIA* later, we find Zippy inside the original *TROJAN HORSE*..

I'm *GLAD* I brought along my SONY *"WALKMAN"!*

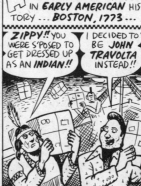

Panel 3: He even played a role in *EARLY AMERICAN* history... *BOSTON, 1773*...

ZIPPY!! You were s'posed to get dressed up as an *INDIAN*!!

I decided to be *JOHN TRAVOLTA* instead!!

Panel 4: And *WHO* do you think supplied "CASUAL" *RONNIE* with all those *ONE-LINERS* last March 30th??

ZIPPY!! I'm *EDWIN MEESE!* We need another *OFF-THE-WALL* GAG for *R.R.!!*

NO MORE until the U.S. gets *OUT OF NORTH AMERICA*, EDWIN...

ZIPPY — "ZIPPY GOES CONSERVATIVE"

© 1981 Bill Griffith

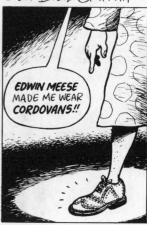

EDWIN MEESE MADE ME WEAR CORDOVANS!!

ZIPPY — "KIDS OF TODAY.. TSK..TSK.."

© 1981 Bill Griffith

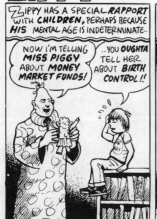

Panel 1: Zippy has a special *RAPPORT* with *CHILDREN*, perhaps because *HIS* mental age is indeterminate..

NOW I'm telling *MISS PIGGY* about *MONEY MARKET FUNDS!*

..YOU OUGHTA tell her about *BIRTH CONTROL!!*

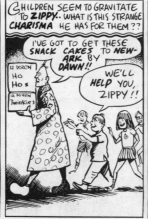

Panel 2: *CHILDREN* seem to gravitate to *ZIPPY*. What is this strange *CHARISMA* he has for them??

I'VE GOT TO GET THESE SNACK CAKES to *NEW-ARK* BY *DAWN!!*

WE'LL HELP YOU, ZIPPY!!

12 DOZEN Ho Ho's

12 DOZEN Twinkies

Panel 3: An ideal *BABYSITTER*, Zippy asks only that all *PRE-TEENS* own *'57 THUNDERBIRDS*..

BUT, ZIPPY.. MY *MOMMY* WILL BE HOME IN *TEN MINUTES!!*

KEEP *DRIVING*, BETSY.. THERE'S A SALE ON *STRETCH SOCKS* DOWN AT THE "7-11"!!

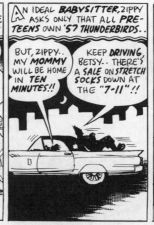

Panel 4: But even *ZIPPY* is perplexed by *KIDS OF TODAY* and their RAMPANT *MATERIALISM*---

LOOK, Timmy.. A *HOUSEWIFE* IS WEARING A *POLYPYRENE JUMP SUIT!!*

"YOU CAN WEAR *ANY-THING* YOU WANT...AS LONG AS THERE'S A *COMMERCIAL* FOR IT!!" *

HE'S A "PEPPER"

* REAL, AUTHENTICATED KID QUOTE!!

ZIPPYISMS

With the generous inheritance from his kindly, old Uncle Maynard, Zippy books passage on a sentimental journey to Mainland China. (Uncle Maynard imported toy birdbaths from Hong Kong for over 40 years—Zippy had an enormous collection). His visit to Peking coincides with the arrival of a U.S. "peace mission". Zippy spots Alexander Haig near the Great Wall two days later and is overcome with emotion. He presents the diplomat with a double-duty Hefty Bag filled to overflowing with tiny, plastic saxophones.

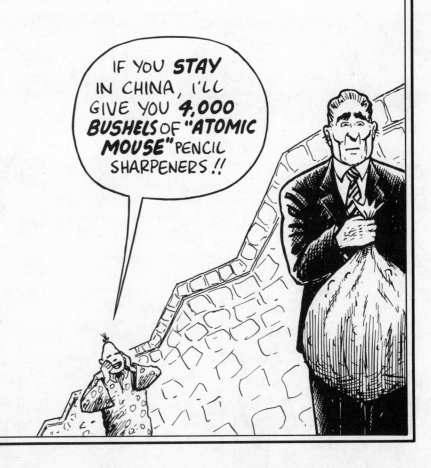

ZIPPY THE PINHEAD

A Dope in High Places

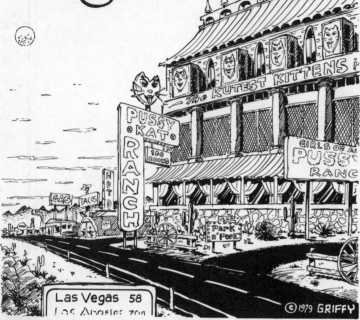

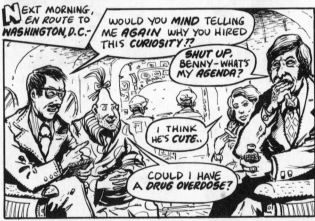

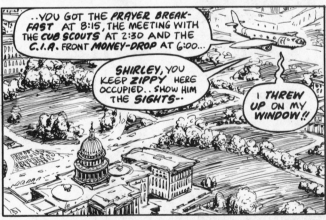

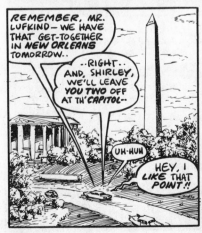

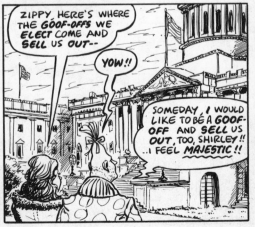

IF I *RUN* DOWN THIS *HALL,* I'LL BE HAVING A *GOOD TIME!!*

ARE YOU GUYS LINED UP FOR THE *METHADONE* PROGRAM OR FOOD STAMPS??

?

OH, *I KNOW* WHAT *THIS* IS!! A BUNCH OF *MR. MUFKIND'S* FRIENDS WHO *ALSO* KNOW *LUKE* FINDS *GOLD* ON HIS LAND!!

EH?

..FUCK THE UNIONS..IF YOU--

YOU MUST BE A *CUB SCOUT!!* HAVE YOU MADE YOUR *MONEY-DROP* TODAY ??

WHY, I--

!

MR. LUFKIND SAYS WE'RE ALL GOING TO *FRY* IN HELL IF THE *GRAM JURY* FINDS OUT *SOMETHING!!*

MY GOD!!

I GUESS WE CAN *LIVE* ON HIS *POT FARM* IN *HADES!!*

"BLUEBONNET"? THIS IS "*BUSTER BROWN*"! LUFKIND'S *COVER* IS BLOWN!! ..THAT'S RIGHT..

I'VE GOTTA *GO,* NOW!! I WANTA TELL YOU YOU'RE A *GREAT* BUNCH OF GUYS BUT YOU OUGHTA *CHANGE* YOUR *UNDERWEAR* MORE OFTEN!!

..THAT WAS A *JOKE!!*

--AM I IN *MILWAUKEE* ??

HI, *BENNY!!* I'M *ALERTING* EVERYONE ABOUT *POTS* AND *PANTS!!*

HEY, *WAIT!!*

COME HERE, YOU!! WE'RE *LEAVING* IN AN HOUR!!

..JUST ENOUGH TIME TO DO MY *LIBERACE* IMPRESSION--

THAN-NK YOU BRO-THER GEORGE AND...

--LOOK WHAT I FOUND *UNESCORTED* IN THE *SENATE* HALLS!!

NICE DECOR!!

GET HIM *SEDATED* --WHEN WE GET BACK, HE'S GOING INTO A *HOME* !!

BAD BOY!!

REP. M. LUFKIND

*A*BOVE *NEW ORLEANS* A FEW HOURS LATER--

BENNY--DID YOU *RETRIEVE* THOSE *TAPES* FROM "*BUSTER BROWN'S*" OFFICE ??

YEH.. AND I PLANTED THE TWO OTHER *BUGS* YOU TOLD ME TO--

GOOD--HEY ZIPPY FINALLY NODDED OUT..

..Y'KNOW, SOMETIMES I GET THE FEELING HE'S A *HELPLESS* KID!!

BAGELS..

UH, YEH..

*M*EANWHILE, INSIDE A *SECLUDED* ESTATE ON *LONG ISLAND*--

..THEN, THAT'S THE *DECISION?*

YES. LUFKIND MUST BE *NEUTRALIZED*...

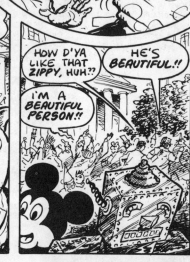
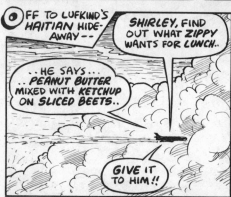

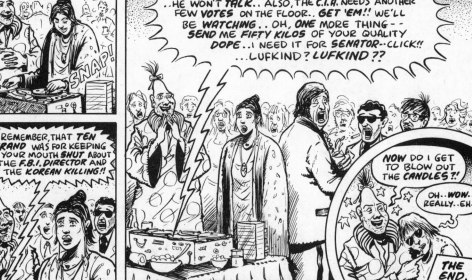

THE END.

Understand Your Nature

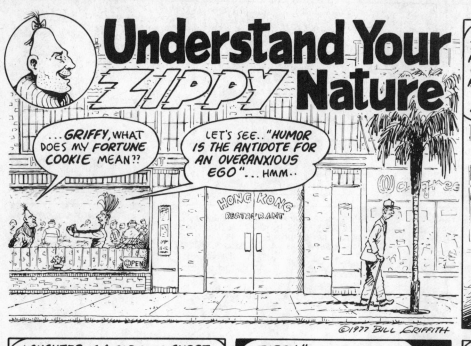

...GRIFFY, WHAT DOES MY *FORTUNE COOKIE* MEAN??

LET'S SEE.. "*HUMOR IS THE ANTIDOTE FOR AN OVERANXIOUS EGO*"...HMM..

©1977 BILL GRIFFITH

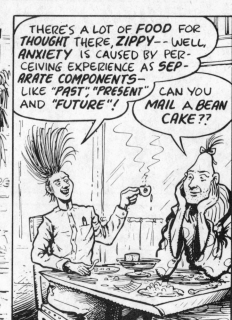

THERE'S A LOT OF *FOOD* FOR *THOUGHT* THERE, *ZIPPY*-- WELL, *ANXIETY* IS CAUSED BY PERCEIVING EXPERIENCE AS SEPARATE COMPONENTS-- LIKE "*PAST*", "*PRESENT*" AND "*FUTURE*"!

CAN YOU *MAIL* A *BEAN CAKE*??

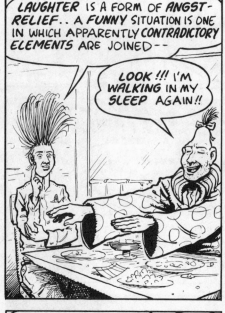

LAUGHTER IS A FORM OF *ANGST-RELIEF*.. A *FUNNY* SITUATION IS ONE IN WHICH APPARENTLY *CONTRADICTORY* ELEMENTS ARE JOINED--

LOOK!!! I'M *WALKING* IN MY *SLEEP* AGAIN!!

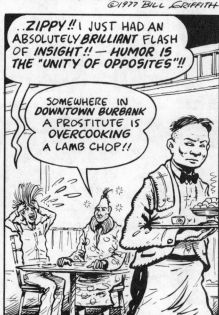

..*ZIPPY*!! I JUST HAD AN ABSOLUTELY *BRILLIANT* FLASH OF *INSIGHT*!! -- HUMOR IS THE "*UNITY OF OPPOSITES*"!!

SOMEWHERE IN *DOWNTOWN BURBANK* A *PROSTITUTE* IS *OVERCOOKING* A *LAMB CHOP*!!

FOR THAT *INSTANT*-- THE *SPASM* OF THE *LAUGH*-- WE ARE RELEASED FROM *MECHANICAL THINKING*!!

I'VE GOT A *COUSIN* WHO WORKS IN THE *GARMENT DISTRICT*...

AND *YOU*!! *ZIPPY*!! YOU ARE THE *EMBODIMENT* OF THAT *PHENOMENON*!!

DON'T SHOOT!!

..YOU SHOULD BE *WORSHIPPED* LIKE A *GOD*!! ..YOU'RE THE WORLD'S MOST *PERFECT* HUMAN BEING!!

UH..BUH-- ..BUH..BUH-- ..BUH...

-I'M LISTENING, *MASTER*!!!

SOMEWHERE IN *TENAFLY, NEW JERSEY*, A *CHIROPRACTOR* IS VIEWING "*LEAVE IT TO BEAVER*"!

HA, HA..MOST *AMUSING*, TAPERED ONE-- YOU PAY *CHECK*??

END

The Good Life

THINK OF IT, SHEILA.. OUR FIRST VACATION IN FOUR YEARS !! ..MY ANALYST WAS ABSOLUTELY RIGHT.. AS SOON AS WE DECIDED TO LEAVE.. I FELT A LOT LESS TENSE.. IT'S GREAT !!

..IT WAS WONDERFUL OF YOUR BOSS AT AEROTECHNICS TO LET YOU HAVE FIVE FULL WEEKS !! AND, JUST IMAGINE, I'LL BE AWAY FROM MY COMPUTER TERMINAL FOR 35 RELAXING DAYS...OH, THAT'S THE DOOR.. IT MUST BE THE HOUSE-SITTER.. ..YOU KNOW, COUSIN FREDA'S NEPHEW.. ..I'LL GET IT, HON---

AM I A WIG SALESMAN OR A TENNIS INSTRUCTOR ?? IS THIS PITTSBURGH OR LAKE TAHOE? I'M HUNGRY.. MY SUITCASE IS OPEN.. THERE ARE BELLS.. AN OR- PHAN IS HUDDLED.. IN A HARDWARE STORE..IS ANYBODY HOME?

©1979 BILL GRIFFITH

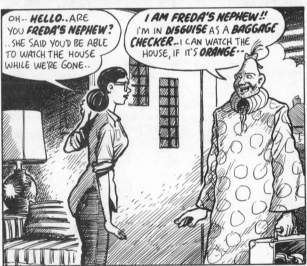

OH.. HELLO..ARE YOU FREDA'S NEPHEW? ..SHE SAID YOU'D BE ABLE TO WATCH THE HOUSE WHILE WE'RE GONE..

I AM FREDA'S NEPHEW!! I'M IN DISGUISE AS A BAGGAGE CHECKER..I CAN WATCH THE HOUSE, IF IT'S ORANGE..

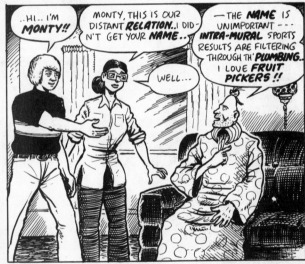

..HI.. I'M MONTY!!

MONTY, THIS IS OUR DISTANT RELATION..I DID- N'T GET YOUR NAME..

WELL...

—THE NAME IS UNIMPORTANT --- INTRA-MURAL SPORTS RESULTS ARE FILTERING THROUGH TH' PLUMBING.. I LOVE FRUIT PICKERS !!

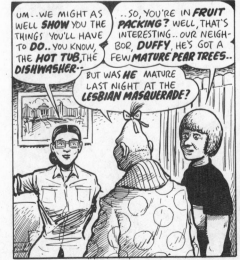

UM..WE MIGHT AS WELL SHOW YOU THE THINGS YOU'LL HAVE TO DO.. YOU KNOW, THE HOT TUB, THE DISHWASHER..

..SO, YOU'RE IN FRUIT PACKING? WELL, THAT'S INTERESTING..OUR NEIGH- BOR, DUFFY, HE'S GOT A FEW MATURE PEAR TREES..

BUT WAS HE MATURE LAST NIGHT AT THE LESBIAN MASQUERADE?

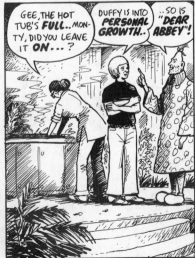

GEE, THE HOT TUB'S FULL.. MON- TY, DID YOU LEAVE IT ON... ?

DUFFY IS INTO PERSONAL GROWTH..

..SO IS "DEAR ABBEY"!

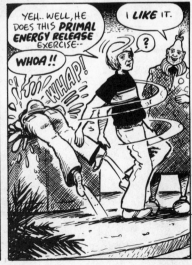

YEH.. WELL, HE DOES THIS PRIMAL ENERGY RELEASE EXERCISE--

I LIKE IT.

?

WHOA !!

WHAP!

49

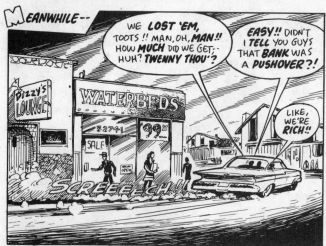

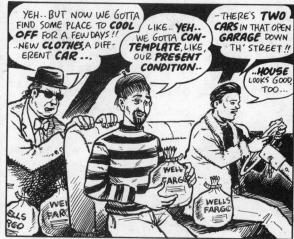

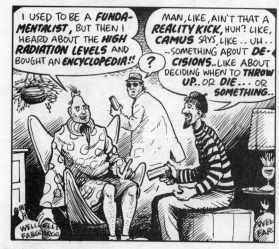

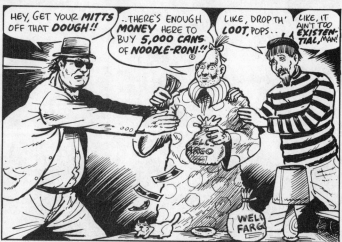

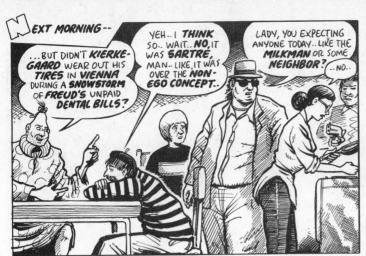

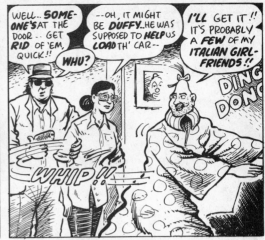

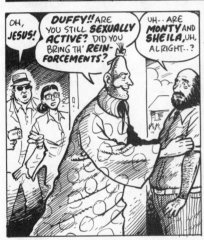

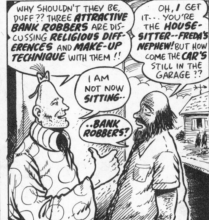

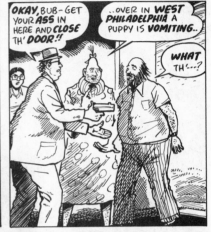

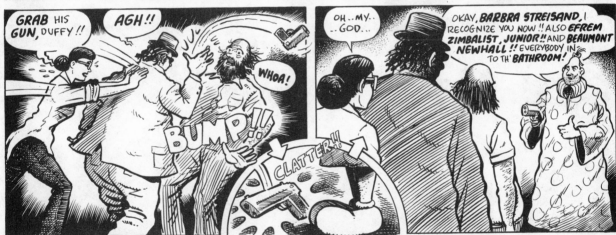

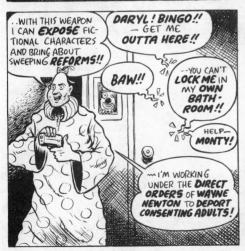

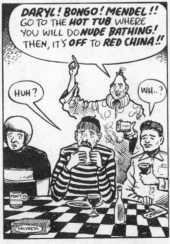

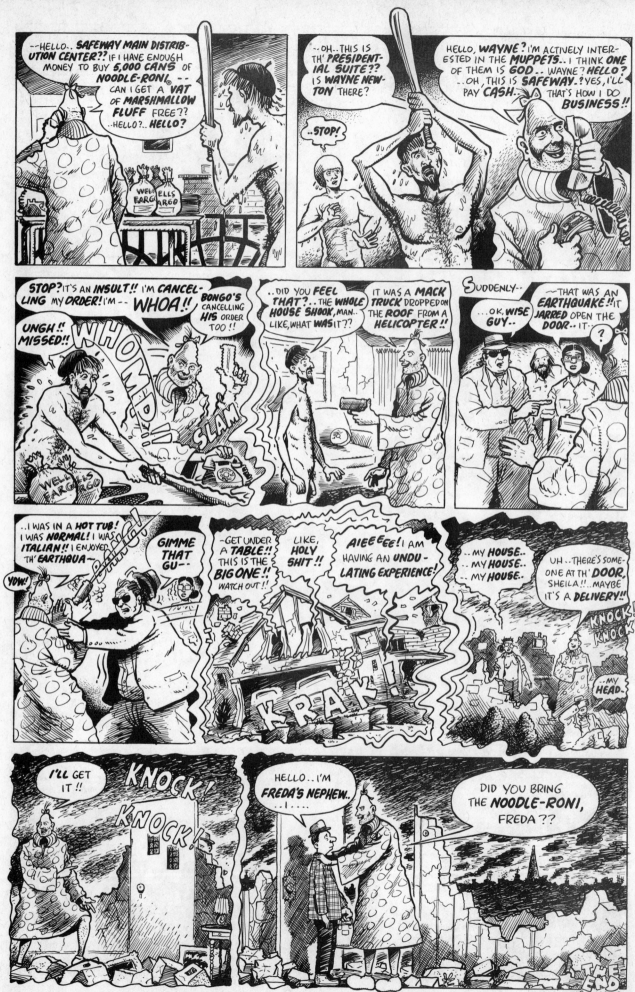

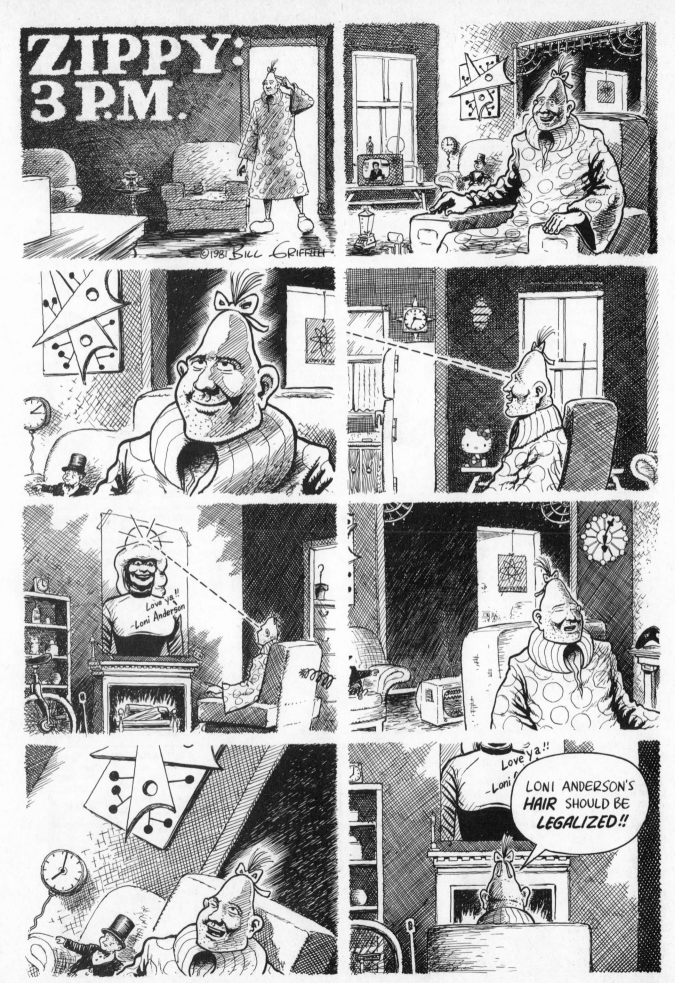

ZIPPYISMS

Zippy is watching an old Dorothy Provine movie on T.V. and listening to all of his *Ramones* albums at once (he has three stereos) when he suddenly remembers the exact latitude and longitude of Newark, New Jersey. He runs out into the street, shouting this revelation to fourteen stunned upholsterers on their way to a bowling tournament.

IT'S **74** DEGREES, **12** MINUTES **NORTH** AND **41** DEGREES, **3** MINUTES **EAST!!** SOON, IT WILL BE **TUESDAY!!**

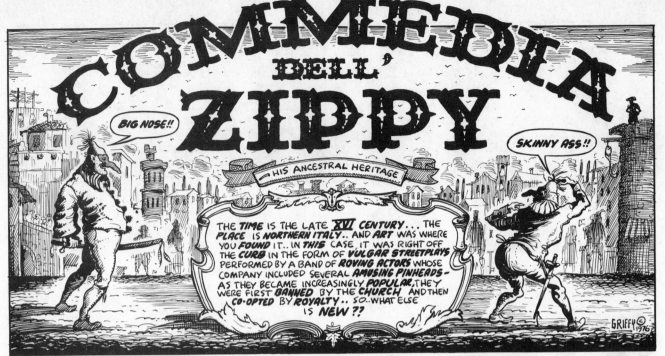

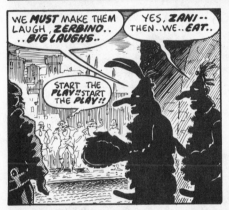

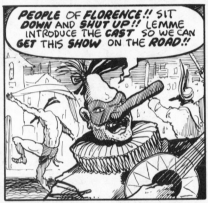

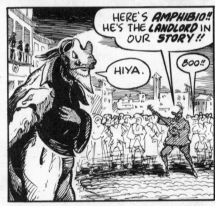

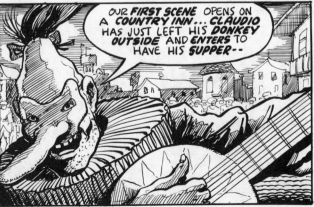

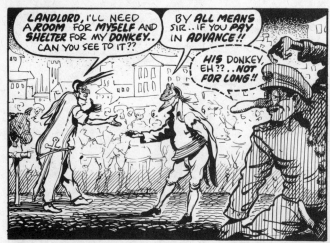

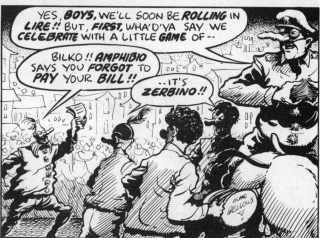

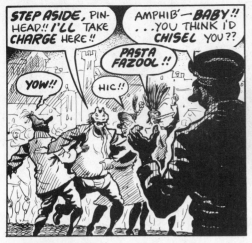

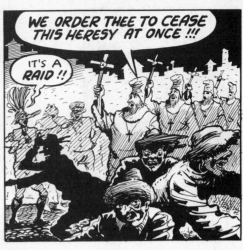

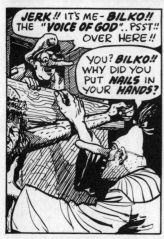

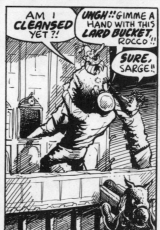

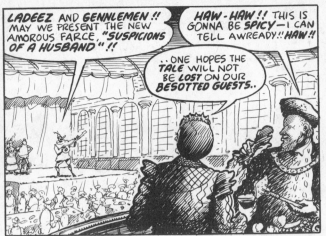

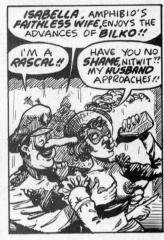

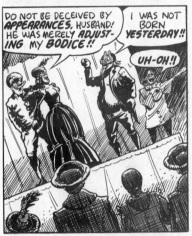

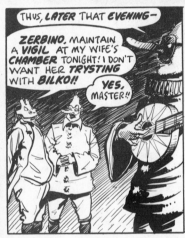

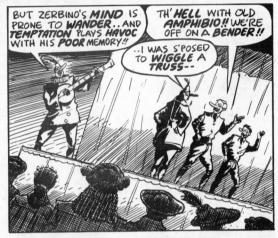

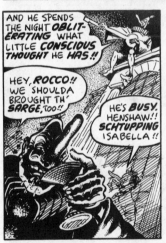

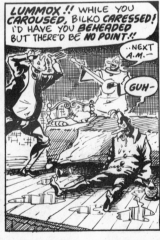

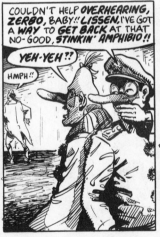

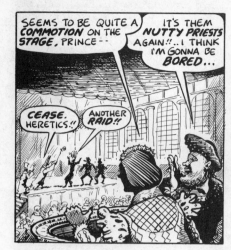

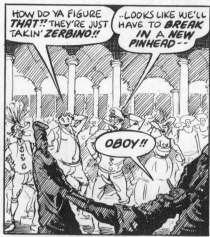

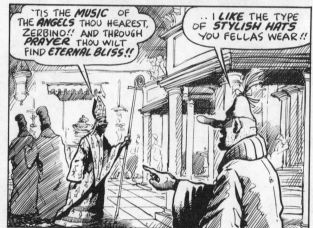

END.

ZIPISTORY

ZIPPY'S A LOT **OLDER** THAN HE LOOKS... IN FACT **EVIDENCE** HAS RECENTLY COME TO LIGHT WHICH INDICATES HE MAY HAVE BEEN A **PASSENGER** ABOARD THE **MAYFLOWER** IN 1620--

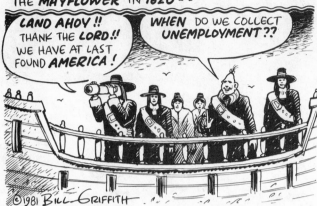

LAND AHOY!! THANK THE **LORD**!! WE HAVE AT LAST FOUND **AMERICA**!

WHEN DO WE COLLECT **UNEMPLOYMENT**??

©1981 BILL GRIFFITH

ZIPPY'S REACTION TO **THOMAS EDISON'S** FIRST PUBLIC DISPLAY OF HIS NEW **MOVING PICTURE MACHINE** PUZZLED **HISTORIANS** UNTIL THIS YEAR---

WELL... WHAT DO YOU **THINK**, ZIPPY??

..IF **ROBERT DI NIRO** ASSASSINATES **WALTER SLEZAK**, WILL **JODIE FOSTER** MARRY **LASSIE**??

THEN, IN **1903**, ACCORDING TO CONTEMPORARY ACCOUNTS, **WILBUR** AND **ORVILLE WRIGHT** WERE GREETED BY AN **UNUSUAL** SIGHT THAT FATEFUL DAY AT **KITTYHAWK**---

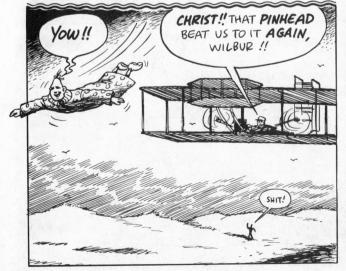

YOW!!

CHRIST!! THAT **PINHEAD** BEAT US TO IT **AGAIN**, WILBUR!!

SHIT!

SKIPPING AHEAD, IT WAS **ZIPPY** WHO, IN 1883, BECAME THE FIRST **INDEPENDENT OWNER** OF THE JUST-COMPLETED **BROOKLYN BRIDGE** ---

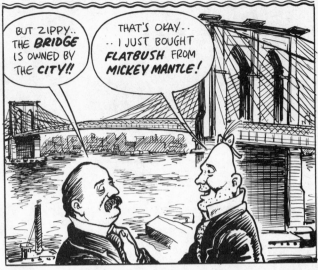

BUT ZIPPY.. THE **BRIDGE** IS OWNED BY THE **CITY**!!

THAT'S OKAY.. ..I JUST BOUGHT **FLATBUSH** FROM **MICKEY MANTLE**!

BACK AGAIN TO **1847** WHEN ZIPPY, A DEEPLY RELIGIOUS PERSON, ACCOMPANIED **BRIGHAM YOUNG** AND THE ORIGINAL **MORMONS** TO THE **UTAH** "PROMISED LAND"---

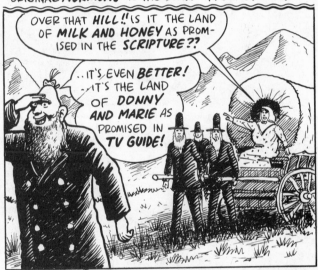

OVER THAT **HILL**!! IS IT THE LAND OF **MILK AND HONEY** AS PROMISED IN THE **SCRIPTURE**??

..IT'S EVEN **BETTER**! ..IT'S THE LAND OF **DONNY AND MARIE** AS PROMISED IN **TV GUIDE**!

OF COURSE, IT ALL **STARTED** BACK IN THE **NEOLITHIC ERA**, WHEN **ZIPPY** CREATED QUITE A **STIR** WITH THE VERY FIRST **WORK OF ART**---

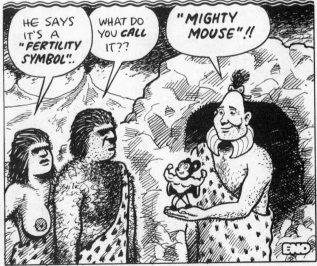

HE SAYS IT'S A "FERTILITY SYMBOL"..

WHAT DO YOU **CALL** IT??

"MIGHTY MOUSE"!!

END

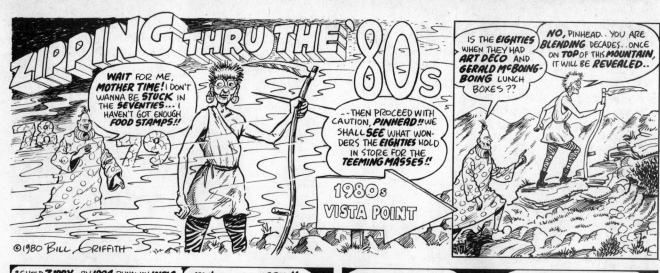

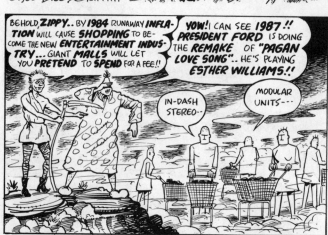

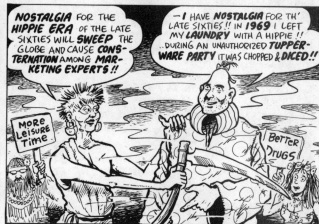

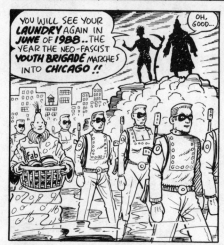

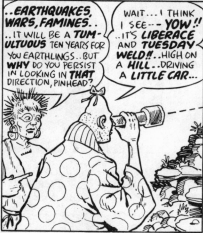

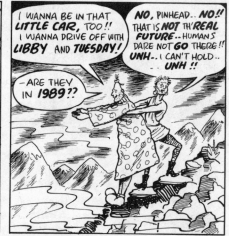

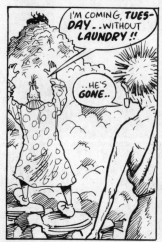

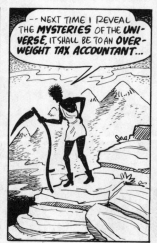

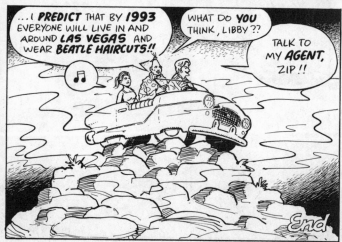

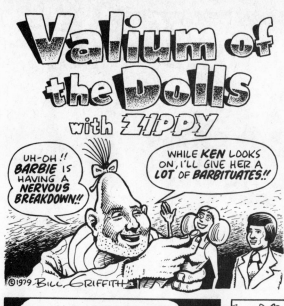

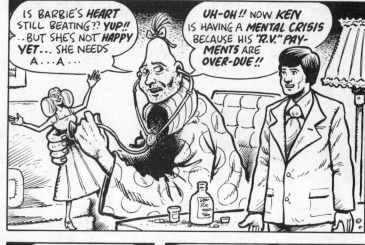

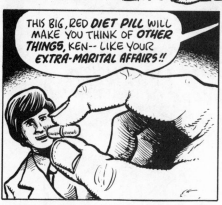

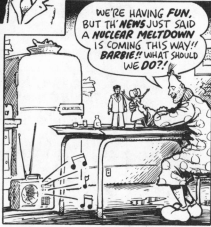

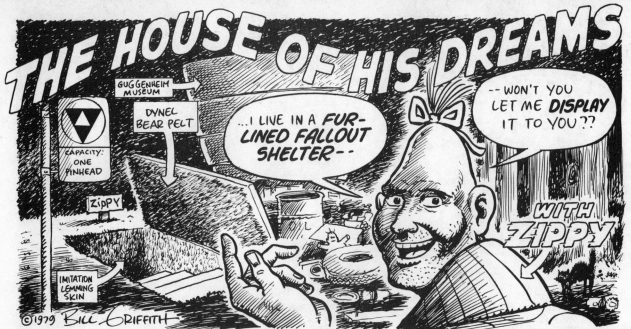

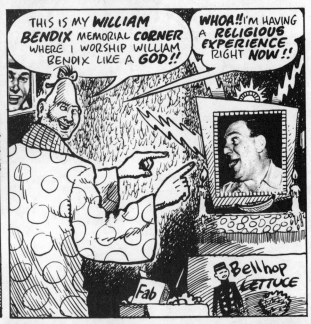

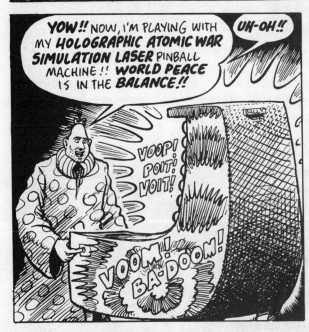

PINHEADS ARE EVERYWHERE

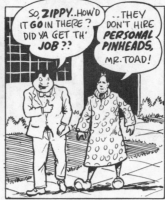

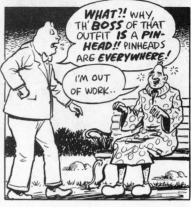

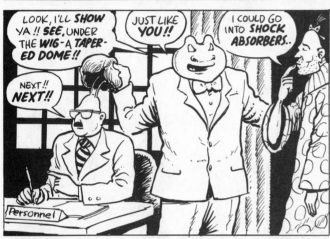

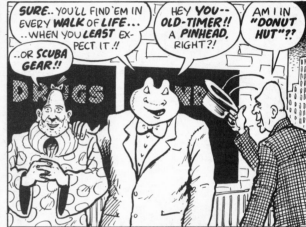

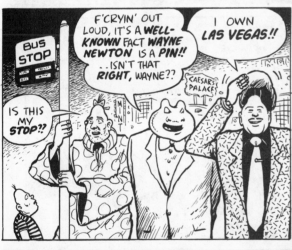

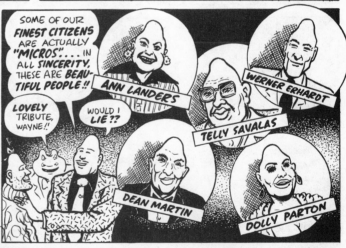

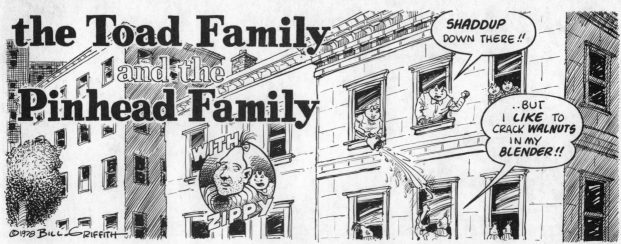

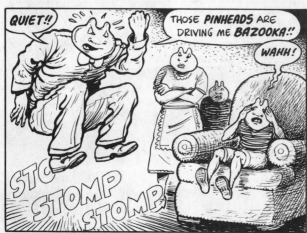

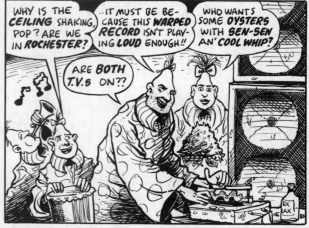

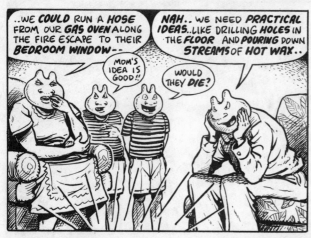

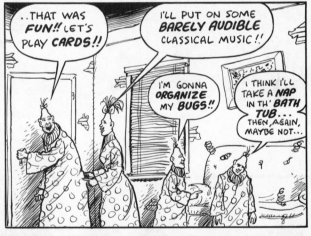

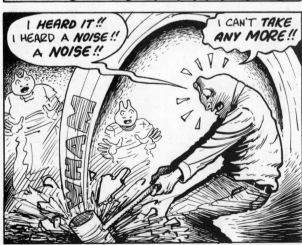

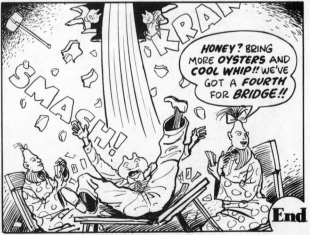

ZIPPY — "HELPFUL HINTS" — ©1980 BILL GRIFFITH

ZIPPY — "MORE HELPFUL HINTS" — ©1980 BILL GRIFFITH

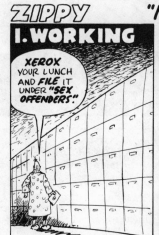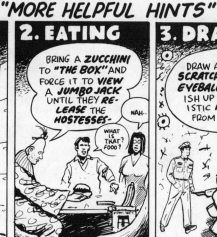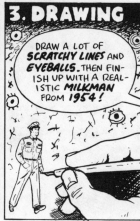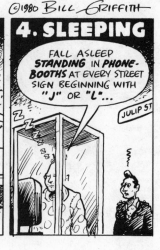

ZIPPY — ZIPPY ALWAYS HAS FUN… "FUN AT ANY PRICE" NO MATTER WHAT HE'S DOING !!! — ©1981 BILL GRIFFITH

ZIPPY — "ZIPPY MEETS PABLO" — ©1980 BILL GRIFFITH

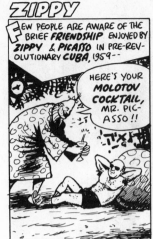
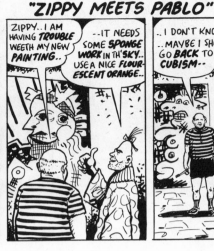
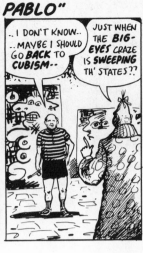
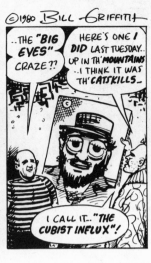

ZIPPY — "ZIPPY MEETS SYLVIA FRUMKIN"* — ©1981 BILL GRIFFITH

ZIPPY — "LONI ANDERSON'S HAIR" — ©1981 BILL GRIFFITH

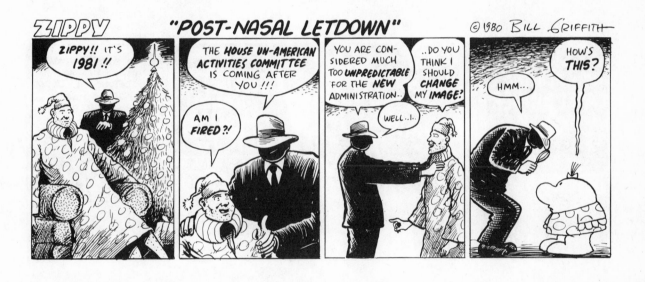

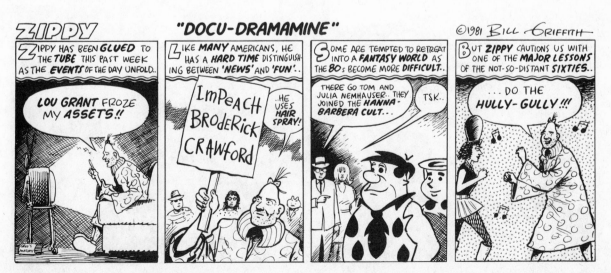

ZIPPY — "LIFE AS WE KNEW IT" — ©1981 Bill Griffith

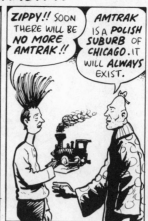
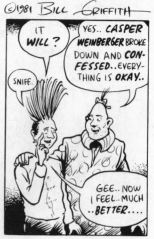

ZIPPY — "CLOSE CALL" — ©1981 Bill Griffith

ZIPPY — "TRIAL RUN" — ©1981 Bill Griffith

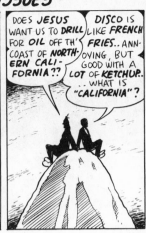
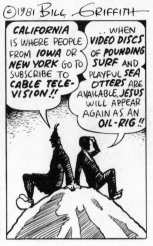

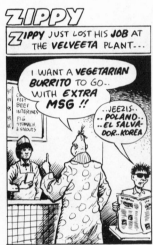
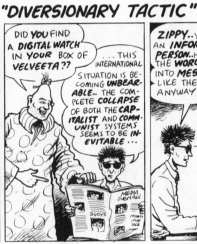
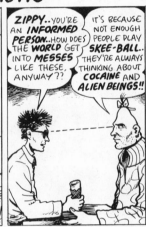
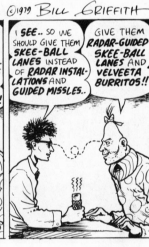

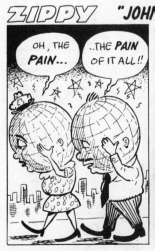
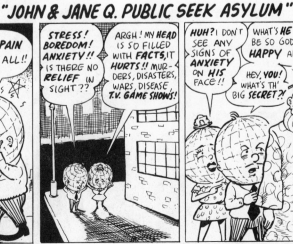

75

ZIPPY — "A TAXING SITUATION" ©1981 BILL GRIFFITH

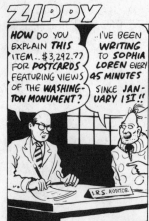
HOW do you explain THIS ITEM.. $3,292.77 for POSTCARDS FEATURING VIEWS OF THE WASHINGTON MONUMENT?

..I'VE BEEN WRITING TO SOPHIA LOREN EVERY 45 MINUTES SINCE JANUARY 1ST!!

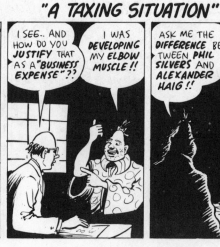
I SEE.. AND HOW DO YOU JUSTIFY THAT AS A "BUSINESS EXPENSE"??

I WAS DEVELOPING MY ELBOW MUSCLE!!

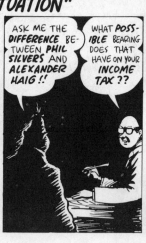
ASK ME THE DIFFERENCE BETWEEN PHIL SILVERS AND ALEXANDER HAIG!!

WHAT POSSIBLE BEARING DOES THAT HAVE ON YOUR INCOME TAX??

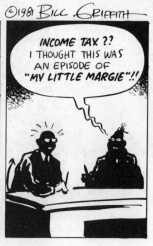
INCOME TAX?? I THOUGHT THIS WAS AN EPISODE OF "MY LITTLE MARGIE"!!

ZIPPY — "HIS SUMMER VACATION" ©1979 BILL GRIFFITH

HE HAD A LOT OF FUN IN NEW YORK CITY..

HE HAD A GREAT TIME IN CONNECTICUT...

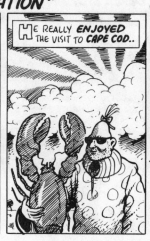
HE REALLY ENJOYED THE VISIT TO CAPE COD..

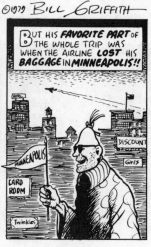
BUT HIS FAVORITE PART OF THE WHOLE TRIP WAS WHEN THE AIRLINE LOST HIS BAGGAGE IN MINNEAPOLIS!!

ZIPPY — "IT'S THE THOUGHT.." ©1978 BILL GRIFFITH

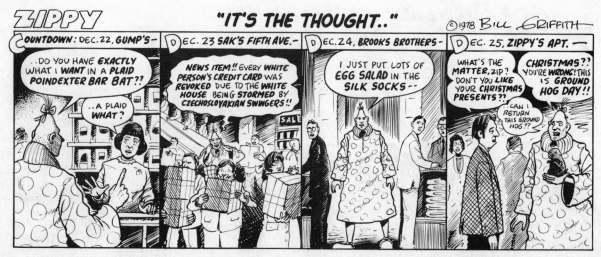
COUNTDOWN: DEC. 22, GUMP'S —
..DO YOU HAVE EXACTLY WHAT I WANT IN A PLAID POINDEXTER BAR BAT??
..A PLAID WHAT?

DEC. 23 SAK'S FIFTH AVE.—
NEWS ITEM!! EVERY WHITE PERSON'S CREDIT CARD WAS REVOKED DUE TO THE WHITE HOUSE BEING STORMED BY CZECHOSLOVAKIAN SWINGERS!!

DEC. 24, BROOKS BROTHERS —
I JUST PUT LOTS OF EGG SALAD IN THE SILK SOCKS--

DEC. 25, ZIPPY'S APT. —
WHAT'S THE MATTER, ZIP? DON'T YOU LIKE YOUR CHRISTMAS PRESENTS??
CHRISTMAS?? YOU'RE WRONG! THIS IS GROUND HOG DAY!!
CAN I RETURN THIS GROUND HOG??

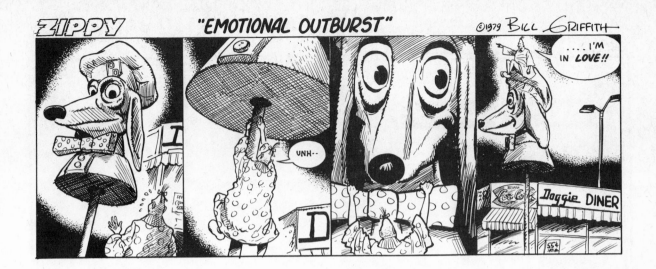

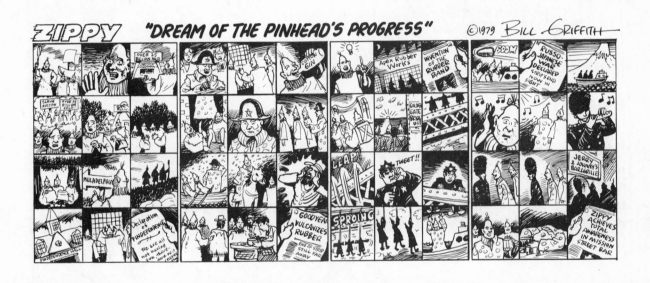

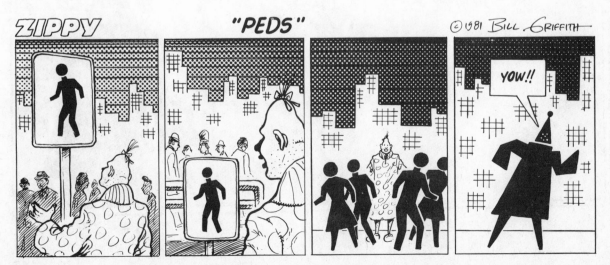

ZIPPYISMS

In order to make a positive statement about life and relationships, Zippy buys a "Sony Walkman", a 36-inch, 8-track stereo "Noise Box" and a pink "Bone-Fone". He puts them all on, turns them up to full volume and strolls down a pleasant country lane outside Davenport, Iowa. Along the way, he discards several containers of Gatorade, an unopened roll of Necco Wafers, a tube of anchovy paste and three pairs of edible underwear. Asked later by a T.V. newsperson what it all meant, Zippy says, "It doesn't mean anything. It was a performance piece".

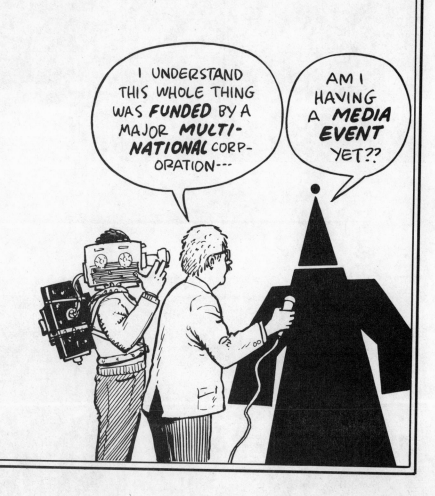

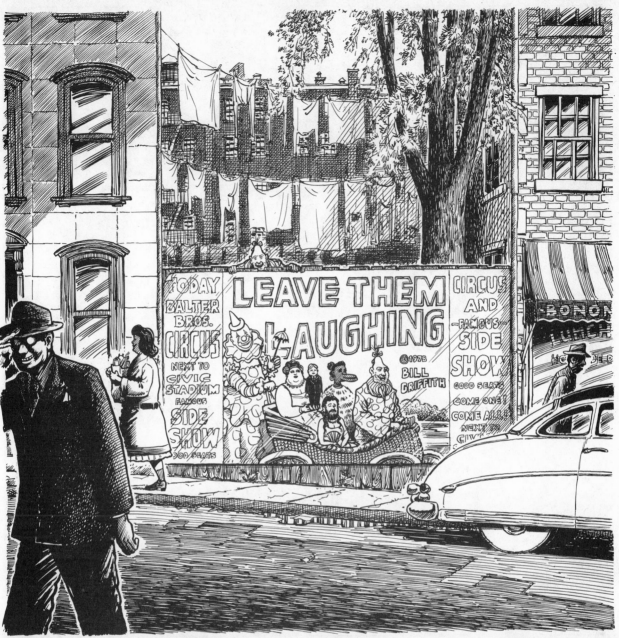

..WHATTA PAIR O' *BLEEDIN'* HEARTS!! "CUTBACK"? HELL, I MADE OLD *BALTER* AXE THE *SIDESHOW!* HE'S *GAGA* FOR ME, TH' *JERK!* HE'LL DO *ANYTHING* I SAY!! WHO CARES ABOUT SOME *PINHEAD!*

YOU GOTTA LOOK OUT FOR *NUMBER ONE*, ROY!!

..I CONVINCED *BALTER* TO GET RID OF TH' *WHOLE* SIDESHOW, SO'S IT WOULDN'T LOOK LIKE I WAS JUST TRYIN' TO HAVE *REVENGE* ON ALFREDO FOR *JILTIN'* ME!!

CHRIST, *MILLIE*, ALL THIS JUST TO *GET BACK* AT YOUR *TATTOOED* BOYFRIEND, *ALFREDO?* ..YOU'RE A *HARD ASS*, YOU ARE!!

..I WOULDN'T LIKE T' BE ON *YOUR* SHIT LIST, MILLIE!

HA HA!

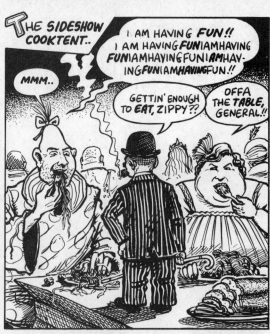

THE SIDESHOW COOKTENT..

I AM HAVING *FUN!!* I AM HAVING *FUN I AM HAVING FUN I AM HAVING FUN I AM HAVING FUN I AM HAVING FUN!!*

MMM..

GETTIN' ENOUGH TO *EAT*, ZIPPY??

OFFA THE *TABLE*, GENERAL!!

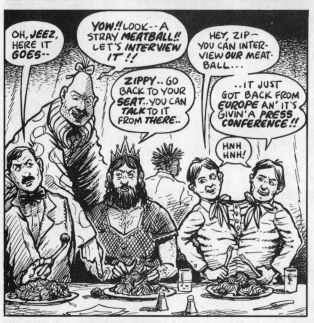

OH, JEEZ, HERE IT GOES--

YOW!! LOOK-- A STRAY *MEATBALL!!* LET'S *INTERVIEW* IT!!

HEY, ZIP-- YOU CAN INTER- VIEW *OUR* MEAT- BALL...

ZIPPY.. GO BACK TO YOUR *SEAT..* YOU CAN *TALK* TO IT FROM *THERE*..

..IT JUST GOT BACK FROM *EUROPE* AN' IT'S GIVIN' A PRESS *CONFERENCE!!*

HNH HNH!

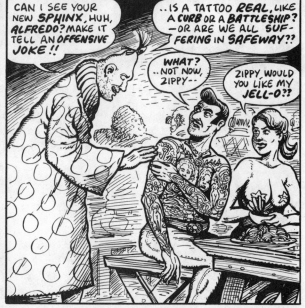

CAN I SEE YOUR NEW *SPHINX*, HUH, ALFREDO? MAKE IT TELL AN *OFFENSIVE* JOKE!!

..IS A TATTOO *REAL*, LIKE A *CURB* OR A *BATTLESHIP?* --OR ARE WE ALL SUF- FERING IN *SAFEWAY??*

WHAT? ..NOT NOW, ZIPPY--

ZIPPY, WOULD YOU LIKE MY *JELL-O*??

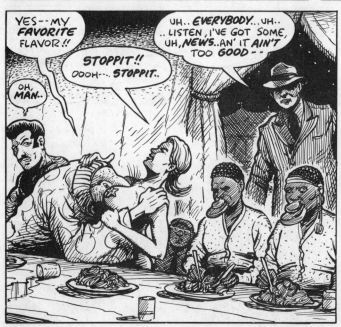

YES-- MY *FAVORITE* FLAVOR!!

STOPPIT!! OOOH--. *STOPPIT..*

OH, MAN..

UH..*EVERYBODY*...UH.. ..LISTEN, I'VE GOT SOME, UH, *NEWS*..AN' IT *AIN'T* TOO *GOOD* --

I JUST GOT WORD FROM TH' *HEAD OFFICE*, FOLKS..IT BREAKS MY HEART TO HAVE TO *TELL* YOU THIS..

BUT..WELL.. TH' *SIDESHOW'S CLOSIN' DOWN*--

NOW WE CAN BECOME *ALCOHOLICS!!*

OH *NO!!*

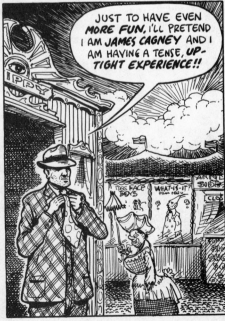

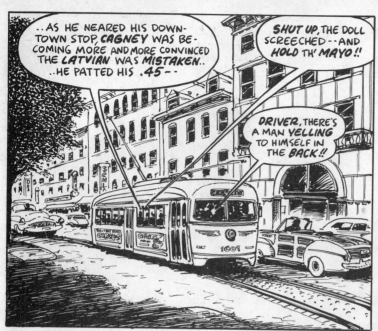

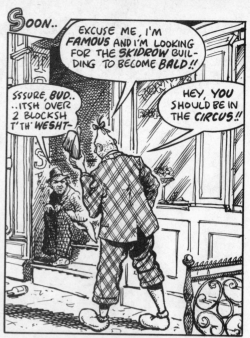

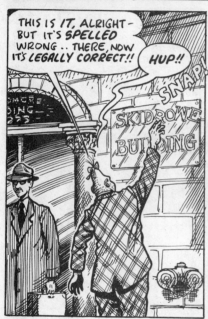

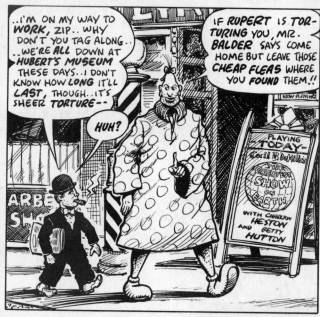

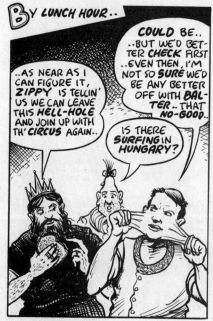

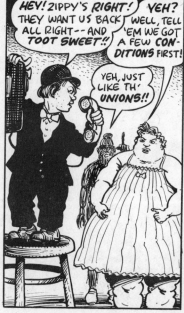

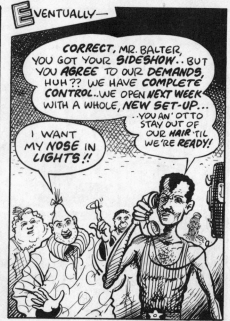

84

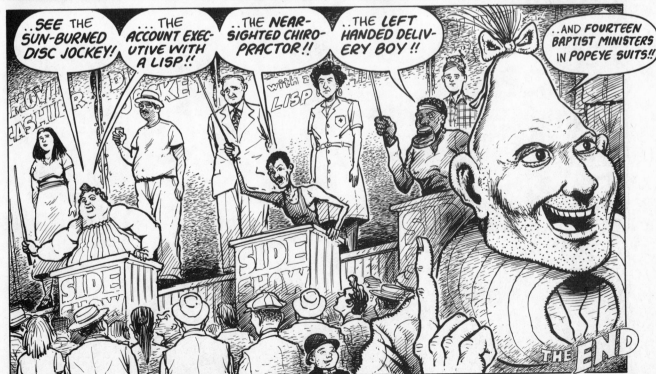

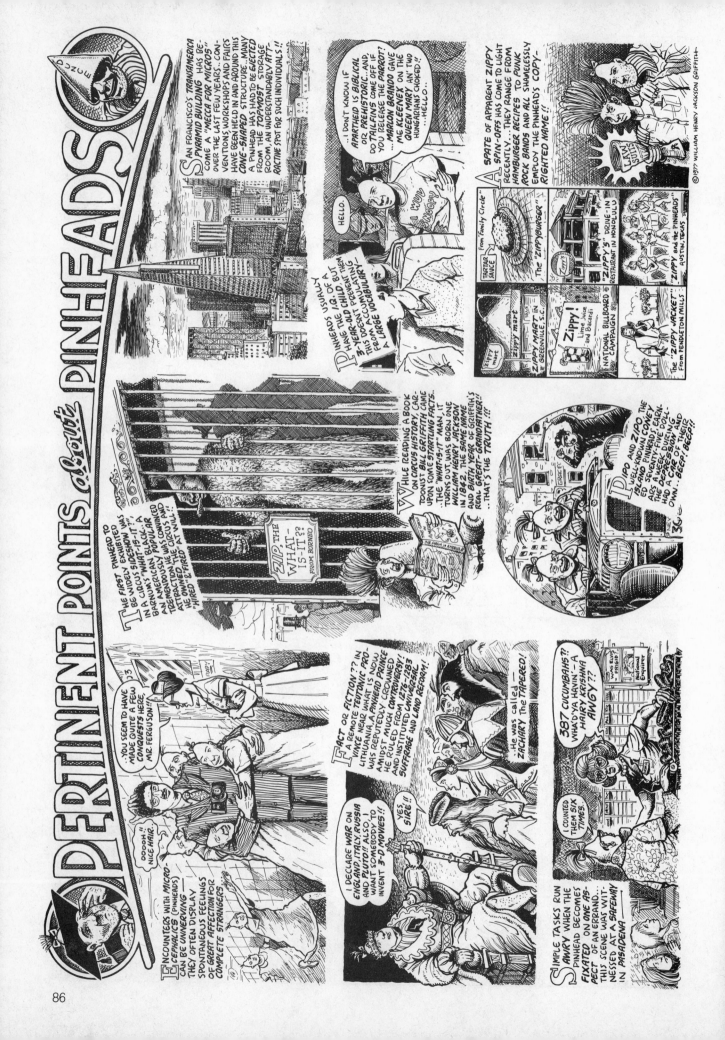

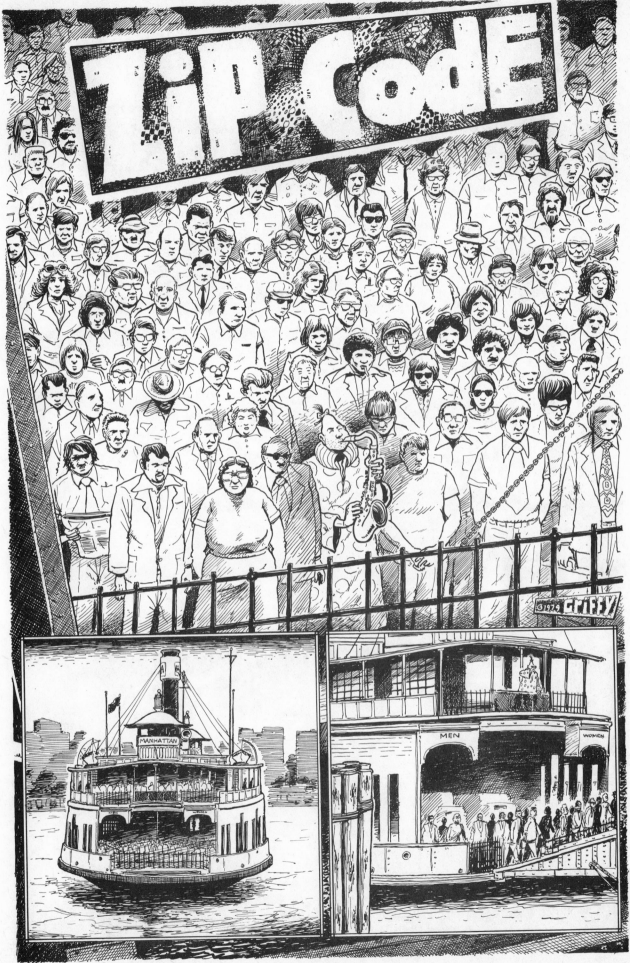

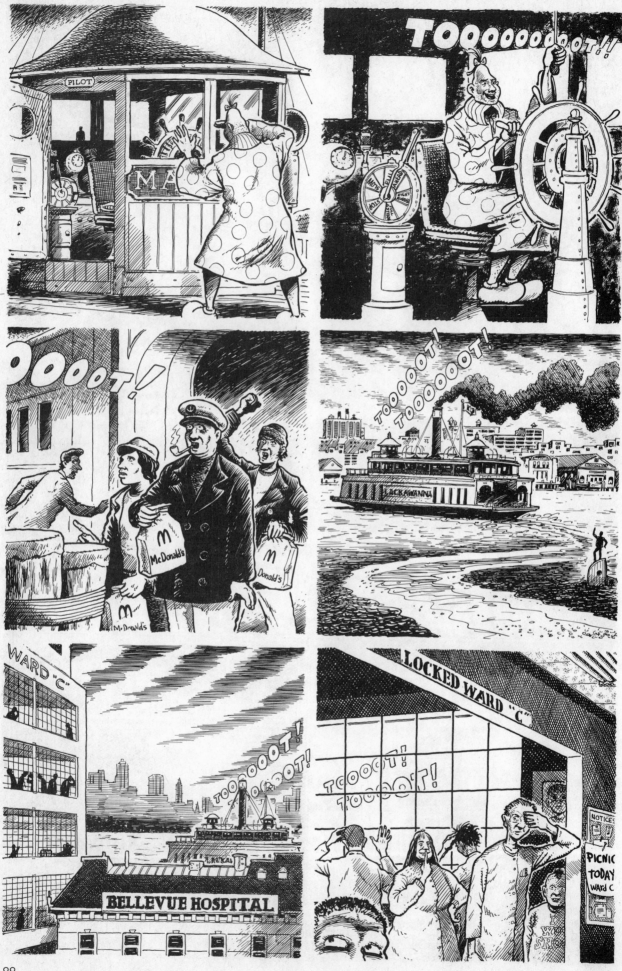

88

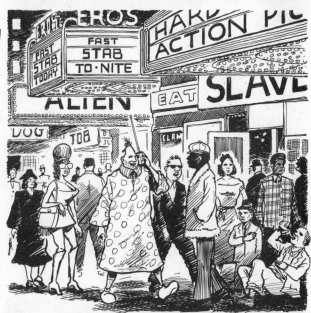
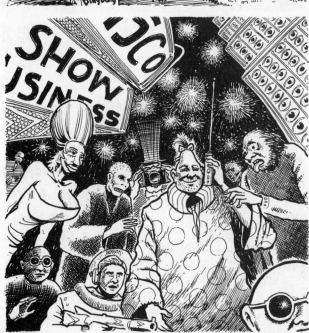
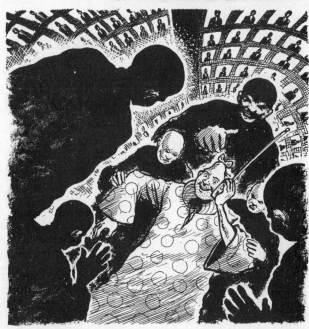

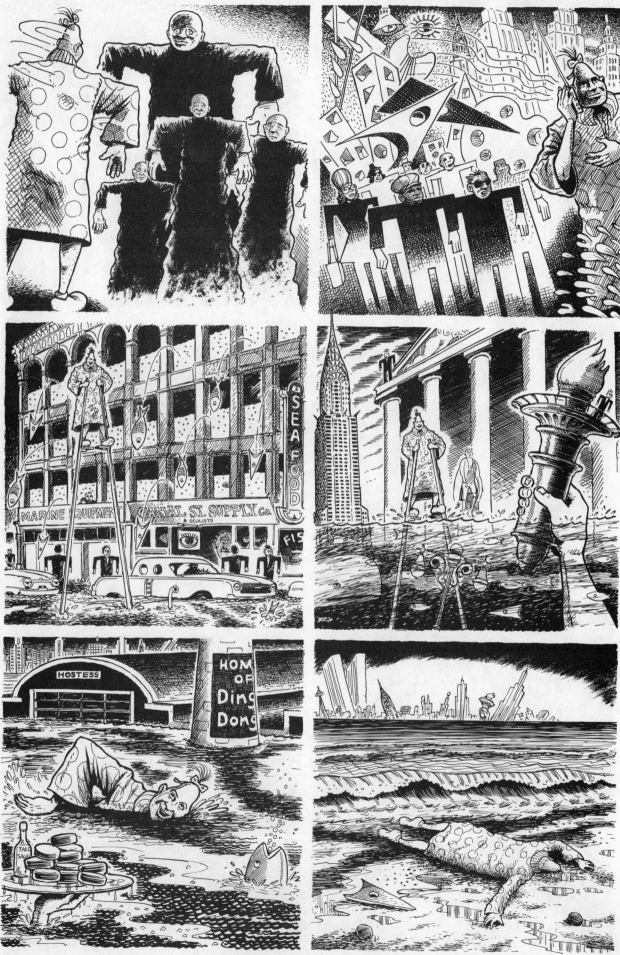

ZIPPY

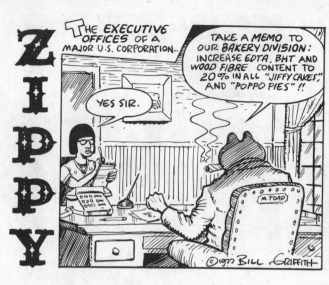

THE EXECUTIVE OFFICES OF A MAJOR U.S. CORPORATION...

TAKE A MEMO TO OUR BAKERY DIVISION: INCREASE EDTA, BHT AND WOOD FIBRE CONTENT TO 20% IN ALL "JIFFY CAKES," AND "POPPO PIES"!!

YES SIR.

M. TOAD

©1977 BILL GRIFFITH

TO OUR PACKAGING DEPT.: ADD THE WORD "NATURAL" TO ALL "BING-BONG" TART WRAPPERS AND UP THE SUGAR CONTENT TO 46%--

AND GET THAT OFFICE-BOY IN HERE! WE'LL NEED HIM FOR SOME PRODUCT TESTING--

YES SIR!

...TH' OFFICE-BOY ???

ZIPPY

GIMME AN ERRAND, BOSS!!

I'VE GOT A LITTLE JOB FOR YOU, ZIPPY, PAL--

FIRST, HAVE A NICE SPOONFUL OF THIS DELICIOUS POLYSORBATE 80!! GOOD, HUH??

MMMM!!

©1977 BILL GRIFFITH

NOW, DIG IN TO THIS PLATE OF HORMONE-SOAKED PORKCHOPS!! --LIKE 'EM??

GMF!

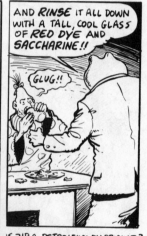

AND RINSE IT ALL DOWN WITH A TALL, COOL GLASS OF RED DYE AND SACCHARINE!!

GLUG!!

IS ZIP A PETROLEUM BY-PRODUCT?

ZIPPY

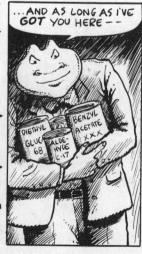

...AND AS LONG AS I'VE GOT YOU HERE--

DIETHYL GLUC-68 ALDE-HYDE C-17 BENZYL ACETATE XXX

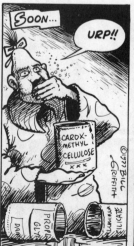

SOON...

URP!!

CARBOX-METHYL CELLULOSE XXX

©1977 BILL GRIFFITH

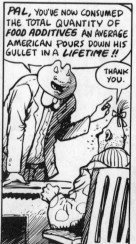

PAL, YOU'VE NOW CONSUMED THE TOTAL QUANTITY OF FOOD ADDITIVES AN AVERAGE AMERICAN POURS DOWN HIS GULLET IN A LIFETIME!!

THANK YOU.

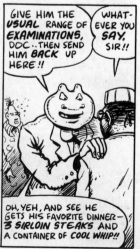

GIVE HIM THE USUAL RANGE OF EXAMINATIONS, DOC..THEN SEND HIM BACK UP HERE!!

WHAT-EVER YOU SAY, SIR!!

OH, YEH, AND SEE HE GETS HIS FAVORITE DINNER- 3 SIRLOIN STEAKS AND A CONTAINER OF COOL WHIP!!

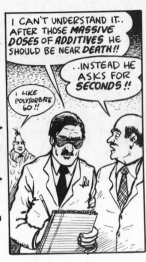

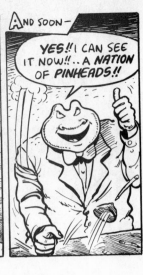

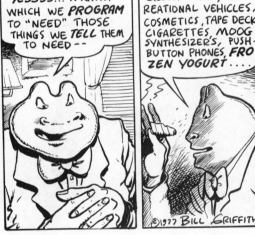
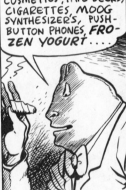

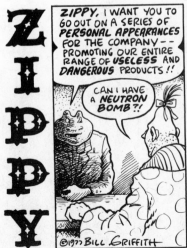

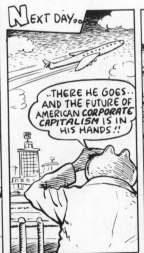
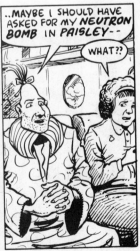

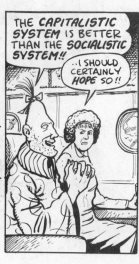
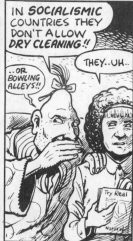

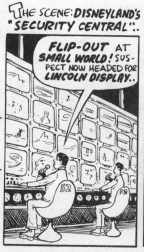
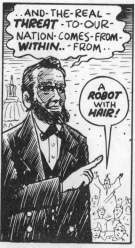
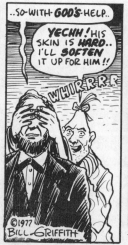
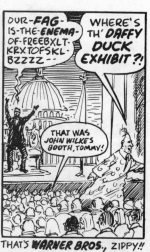

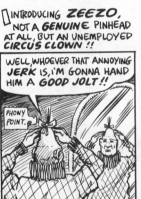

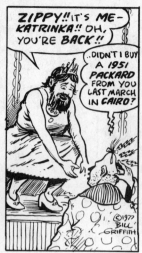

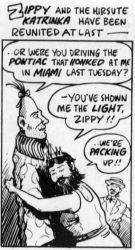
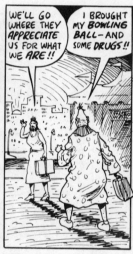

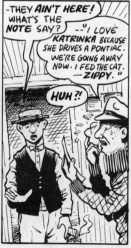
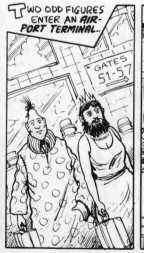
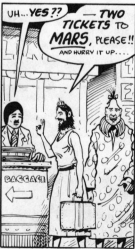

ZIPPY

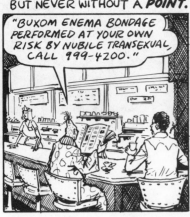

ON THE ROAD, *ZIPPY* IS A PINHEAD WITHOUT A PURPOSE, BUT NEVER WITHOUT A *POINT*.

"BUXOM ENEMA BONDAGE PERFORMED AT YOUR OWN RISK BY NUBILE TRANSEXUAL. CALL 999-4200."

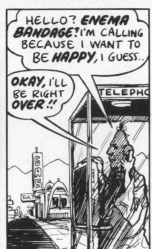

HELLO? *ENEMA BANDAGE*!? I'M CALLING BECAUSE I WANT TO BE *HAPPY*, I GUESS..

OKAY, I'LL BE RIGHT *OVER!!*

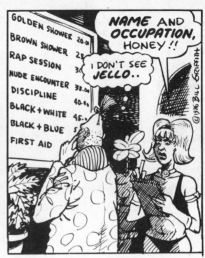

GOLDEN SHOWER	20.00
BROWN SHOWER	25.
RAP SESSION	30
NUDE ENCOUNTER	38.00
DISCIPLINE	40.00
BLACK + WHITE	45.
BLACK + BLUE	5
FIRST AID	

I DON'T SEE *JELLO*..

NAME AND *OCCUPATION*, HONEY!!

© 1976 BILL GRIFFITH

ZIPPY

LESSONS IN *SEXUALITY* DO NOT EASILY PENETRATE ZIPPY'S TAPERED *CRANIUM*—

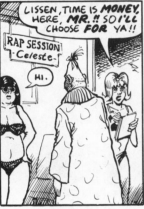

RAP SESSION -Celeste-

HI.

LISSEN, TIME IS *MONEY* HERE, *MR.*!! SO I'LL CHOOSE *FOR* YA!!

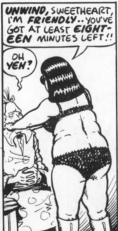

UNWIND, SWEETHEART, I'M *FRIENDLY*.. YOU'VE GOT AT LEAST *EIGHTEEN* MINUTES LEFT!!

OH YEH?

HERE— LET'S *UNDO* YOUR BOW.. DON'T BE *UPTIGHT!*

I'M GETTING *DOWN.* I'M *FUNKY.*

THERE.. NOW, WHAT WOULD YOU LIKE TO *TALK* ABOUT— *FAMILY PROBLEMS?*

HOW *SAD.*

..MY *PANTS* JUST WENT ON A *WILD RAMPAGE* THRU A *LONG ISLAND BOWLING ALLEY!!*

© 1977 BILL GRIFFITH

...IS *ZIP* ALL *TALK?*

ZIPPY

ZIPPY THINKS HE IS BEING HELD *CAPTIVE* IN A *MASSAGE PARLOR*

I DON'T *WANT* TO BE *PORNOGRABBIK*!!

HEY, YOU STILL GOT *FOURTEEN* MINUTES!

ON THE WAY OUT, HE STOPS AT A MAGAZINE RACK—

I FEEL LIKE I'M IN A *TOILET BOWL* WITH A *THUMBTACK* IN MY *FOREHEAD!!*

NEW *HUSTLER* JUST OUT!

WHERE *TO*, BUD?

I GOTTA *LEAVE* TH' COUNTRY!!

AIR-PORT, HUH?

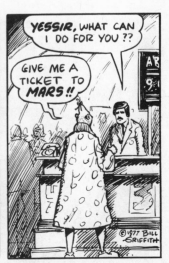

YESSIR, WHAT CAN I DO FOR YOU??

GIVE ME A TICKET TO *MARS!!*

© 1977 BILL GRIFFITH

ZIPPY

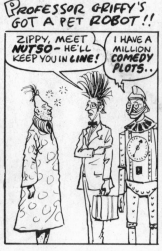 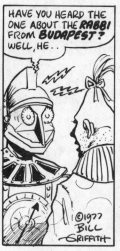 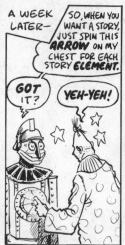

ZIPPY

ZIPPY

 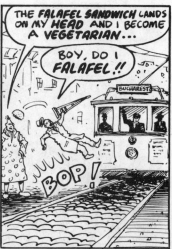

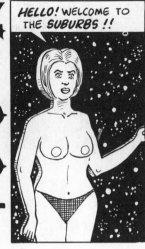
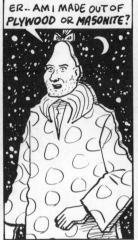
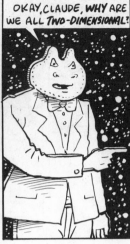

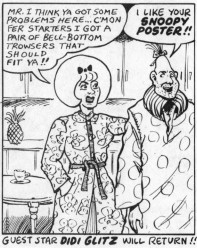

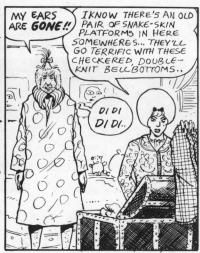
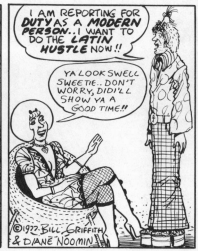
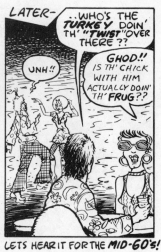

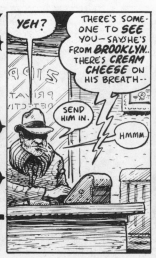
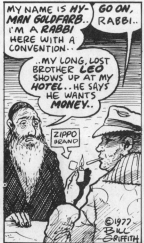
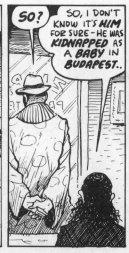
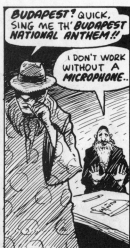

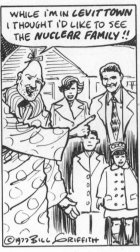
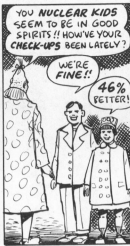

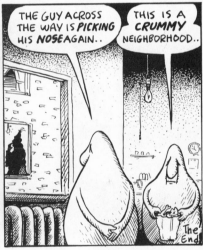

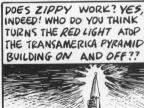
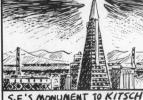

ZIPPYISMS

Zippy is standing on line at the Post Office, waiting to mail a jumbo jar of organic mayonnaise to his local Congressman to register his feelings about the draft. Just before it's his turn at the Air Express window, he notices the woman ahead of him has an ear protruding from her hair. After asking her if there is still inflation on Venus, he lets her in on a well-kept secret:

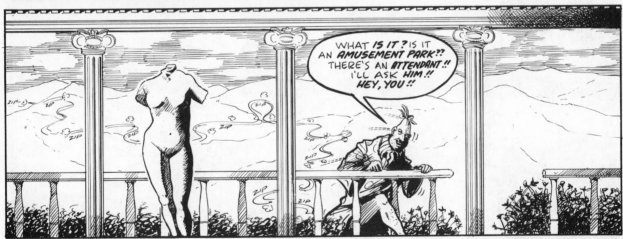
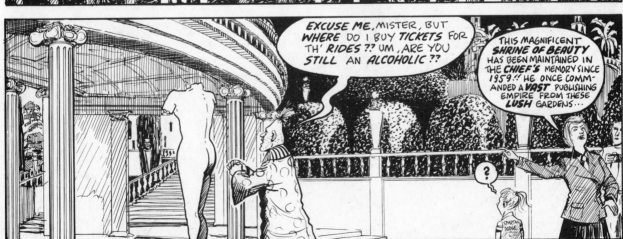

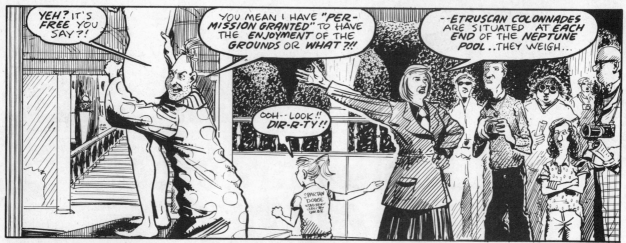

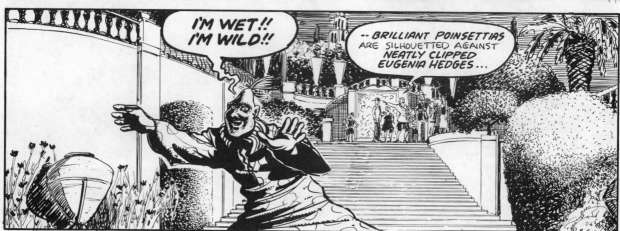

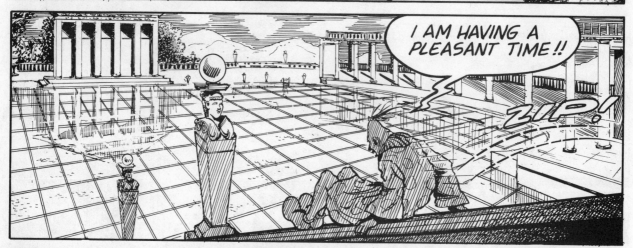

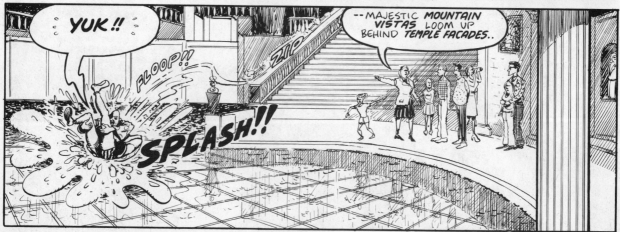

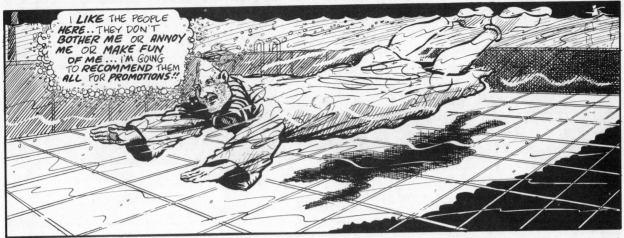

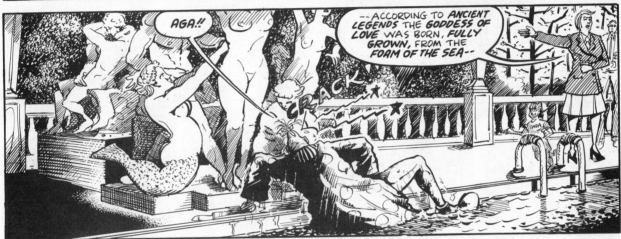

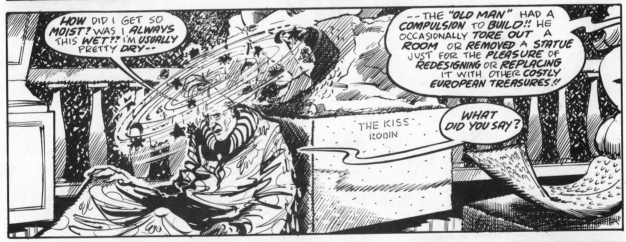

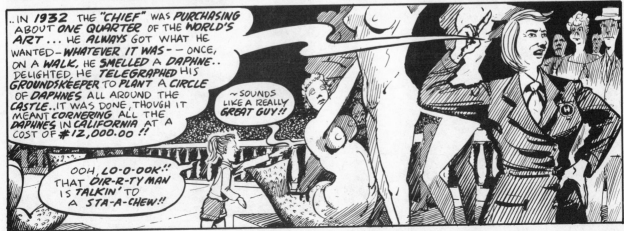

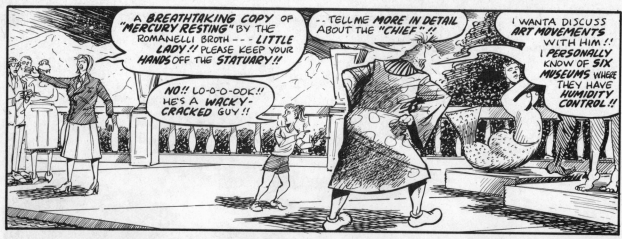

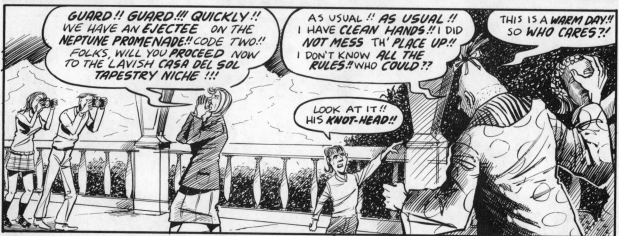

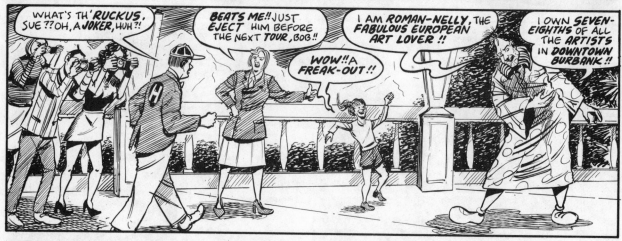

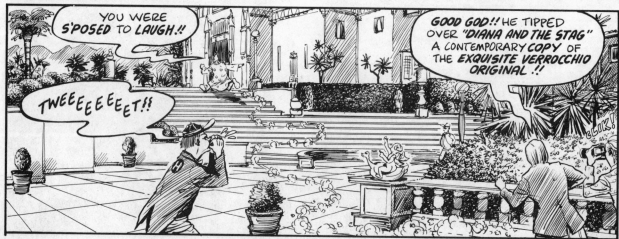

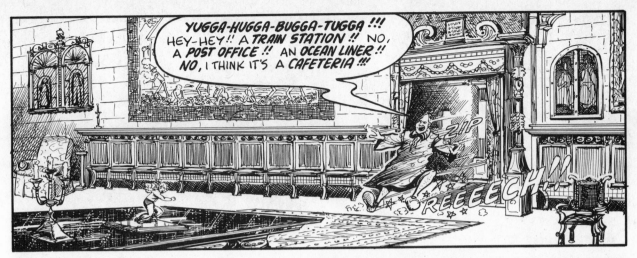

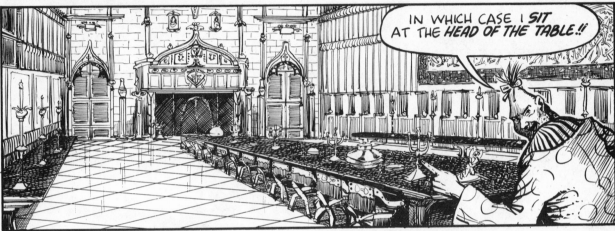

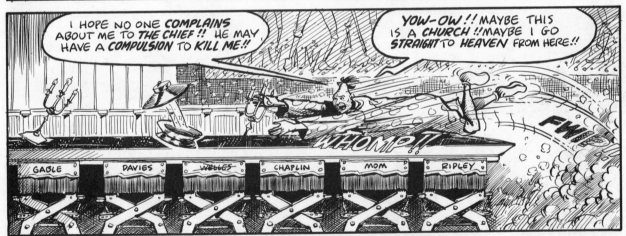

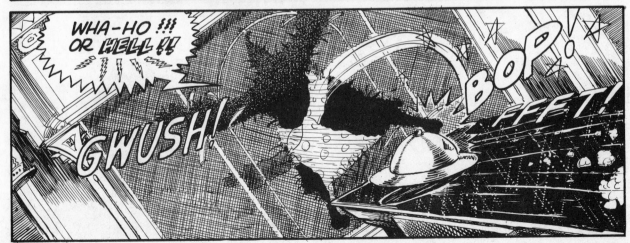

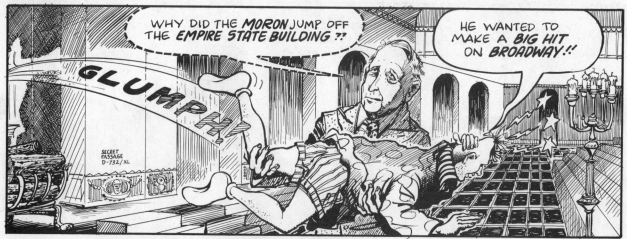

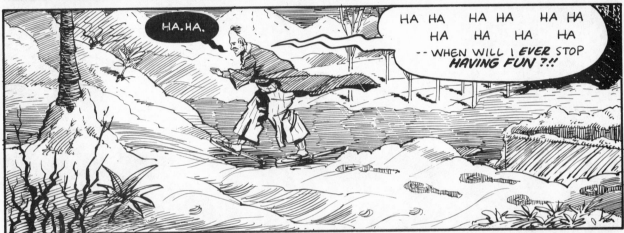

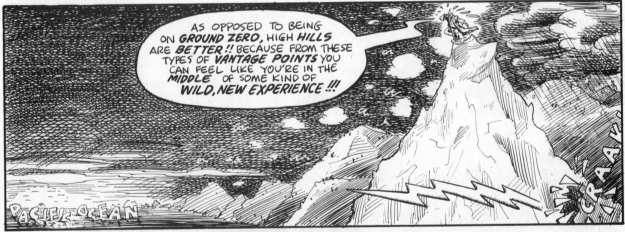

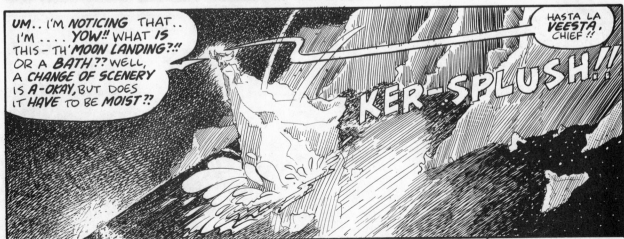

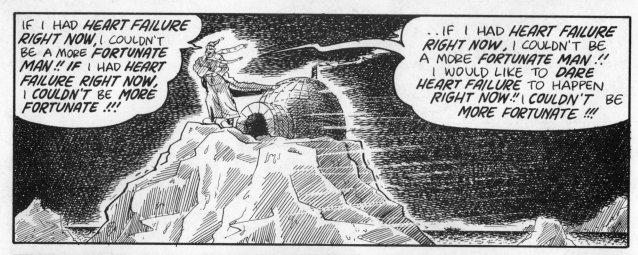

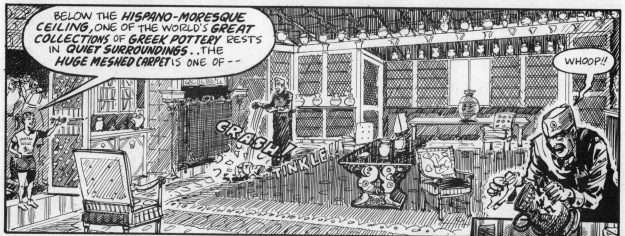

THE END.

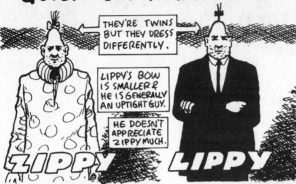

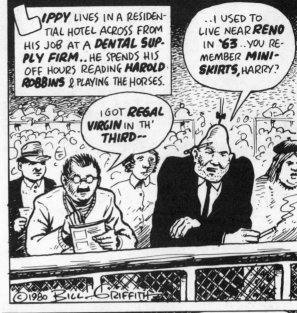

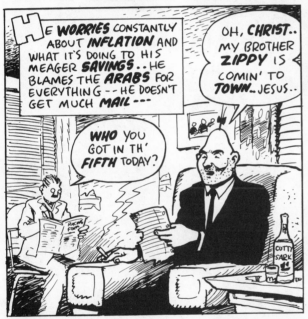

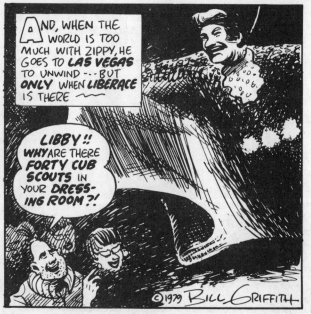

114

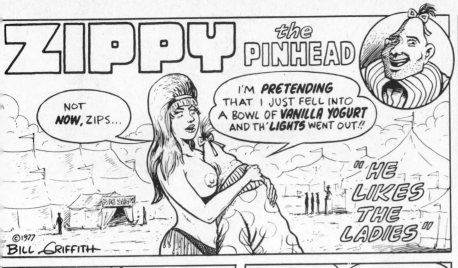
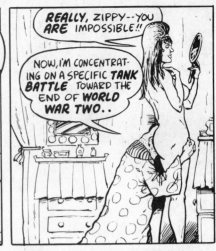
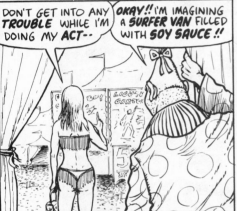
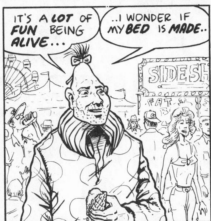
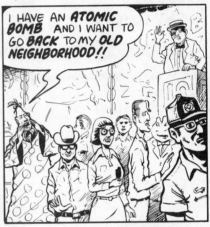

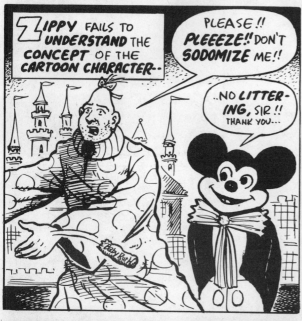

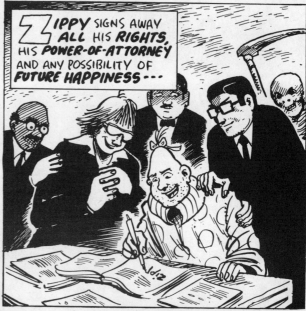

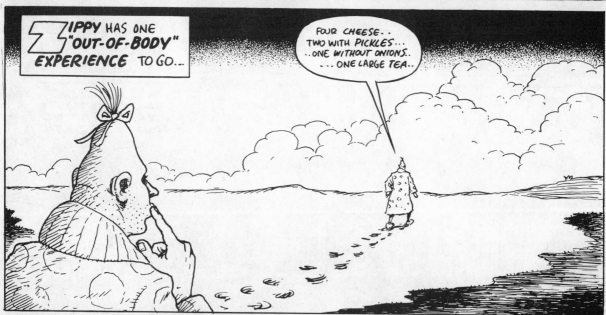

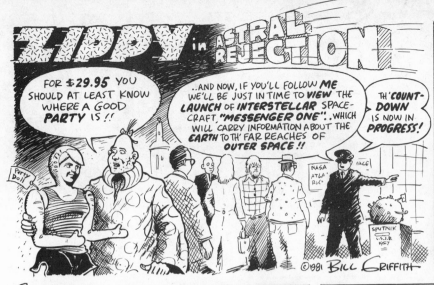

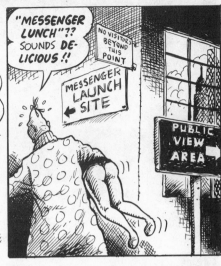

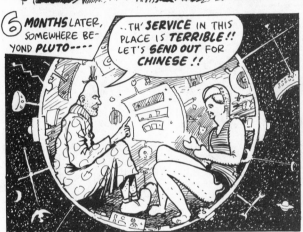

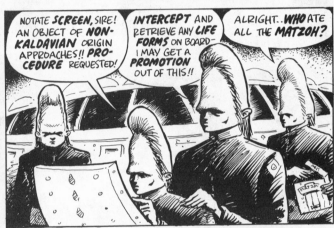

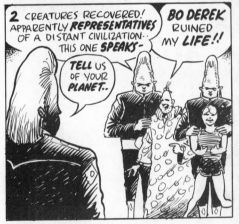

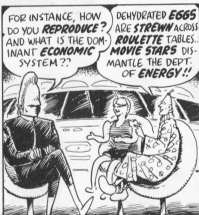

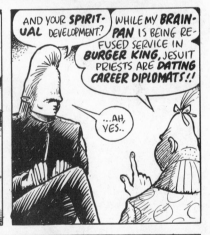

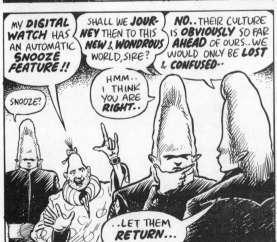

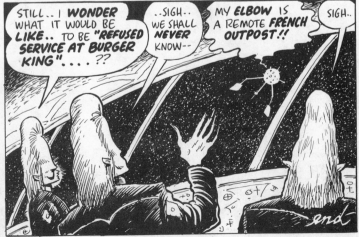

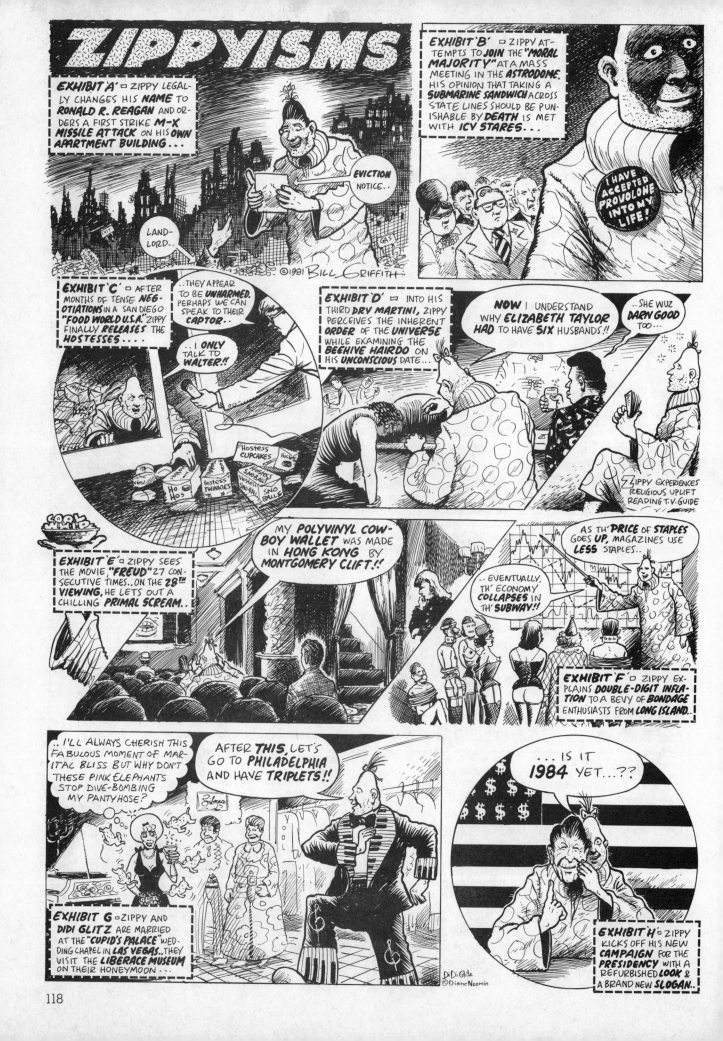

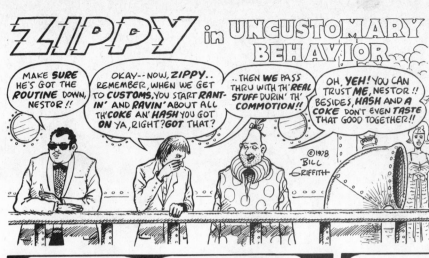

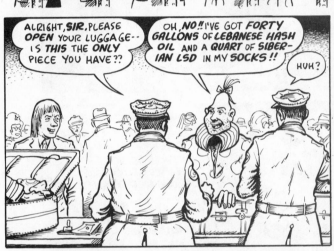

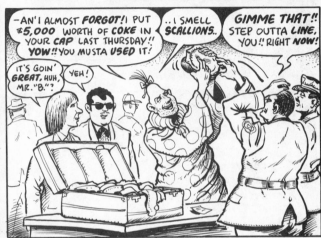

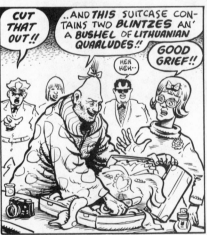

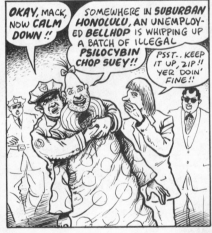

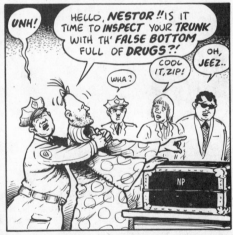

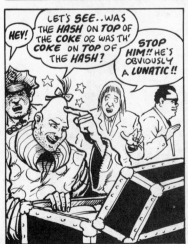

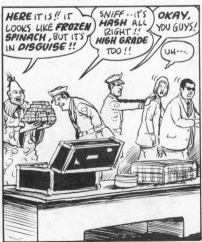

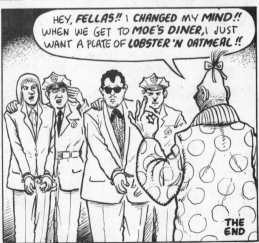

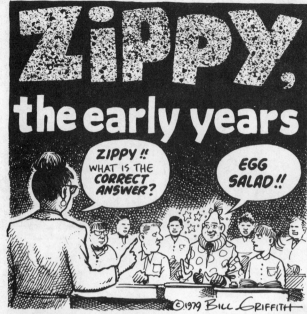

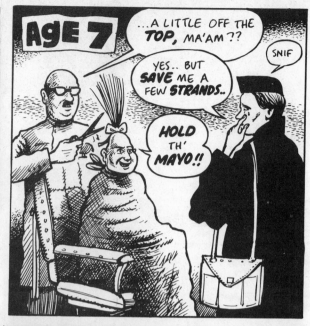

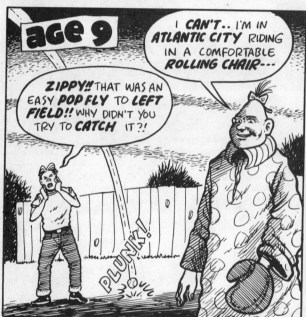

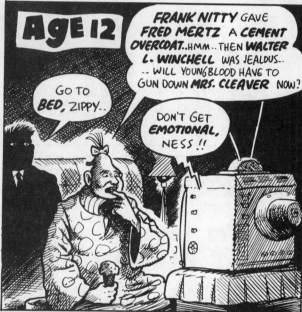

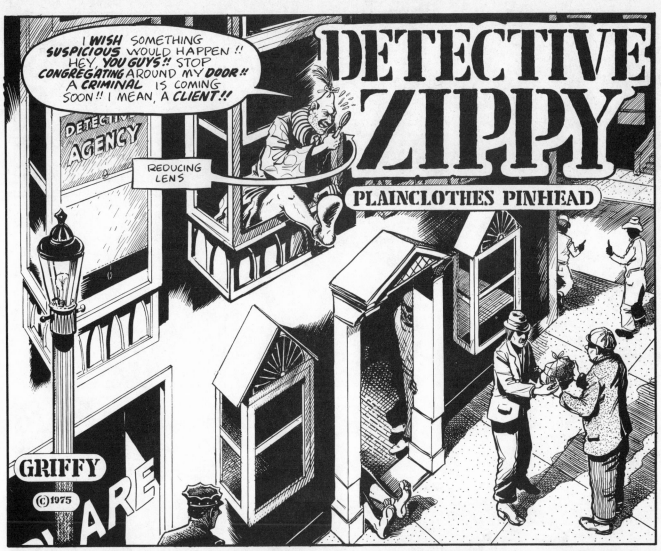

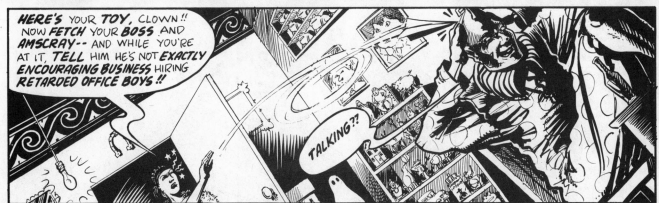

123

ZIPPYISMS

Zippy is in Long Island City for a Tupperware convention. After the desk clerk at the local "Bide-a-Wee Motel" has finally convinced Zippy there *is no* Tupperware convention in Long Island City, he gets on a bus for Sparks, Nevada. Upon arrival there, he puts 50¢ in a slot machine and pulls the handle. Behind him, across the street, a building slated for demolition explodes in a cloud of dust and crumbles neatly to the ground. Just then, Zippy hits a $500.00 jackpot and declares that everyone in Long Island City is now named "Beryl".

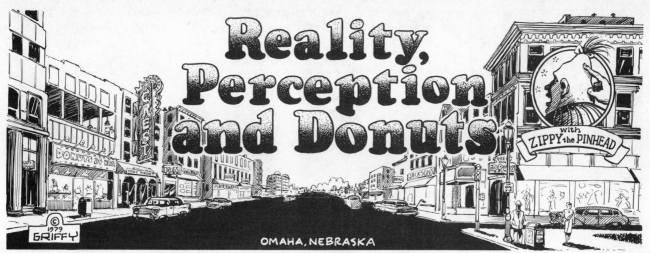

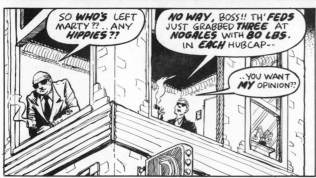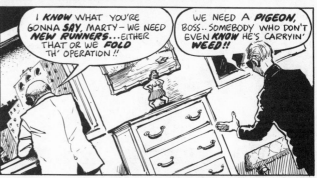

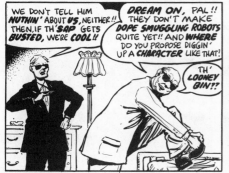

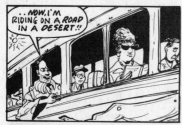

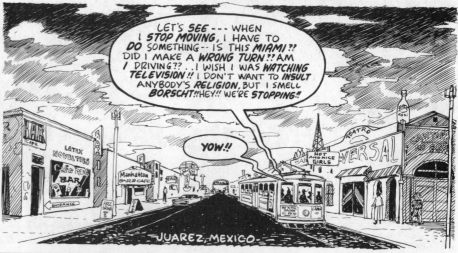

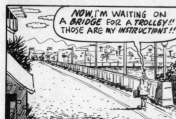

JUAREZ MEXICO

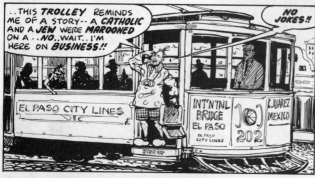

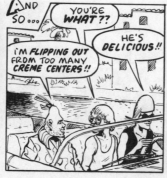

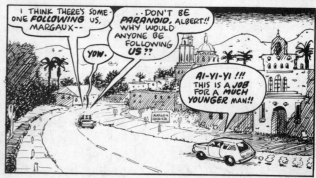

126

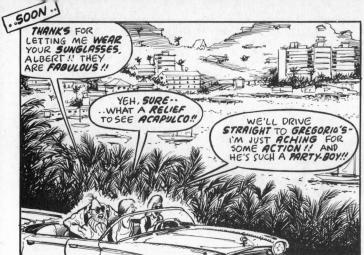
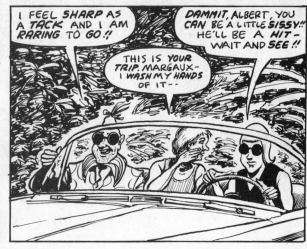

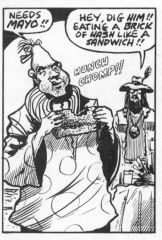
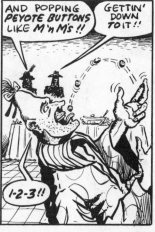

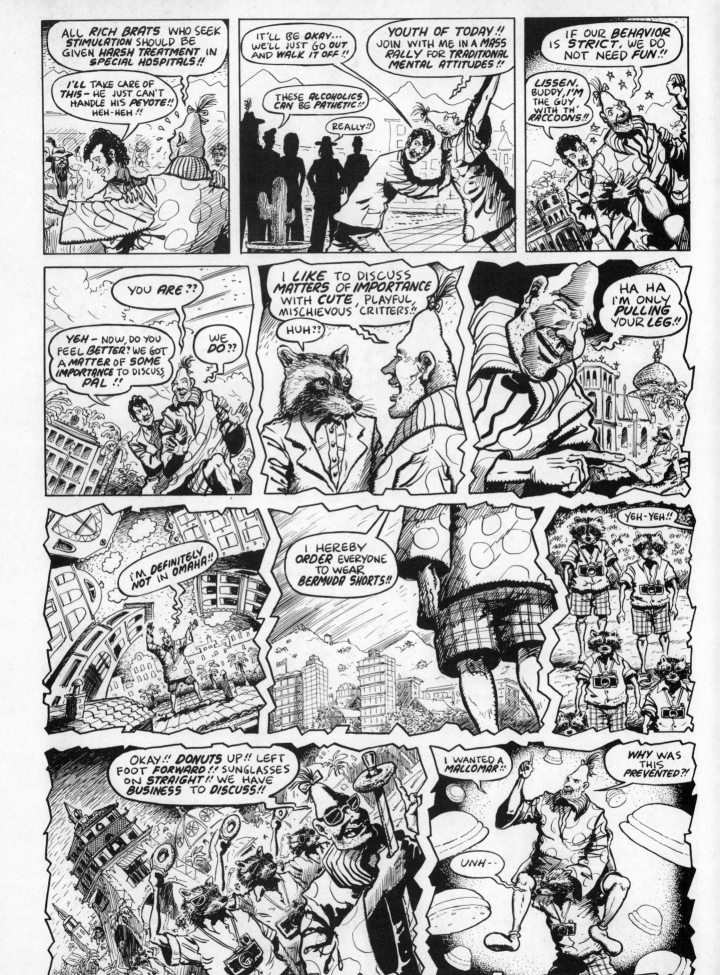

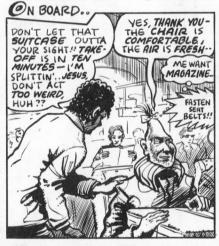

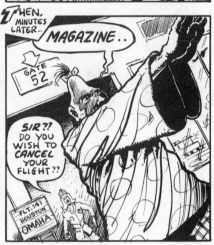

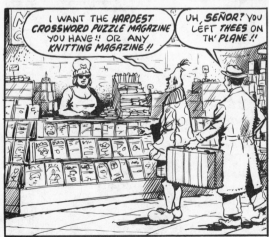

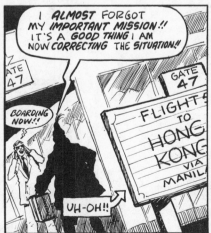

WHEN WE GET TO *OMAHA*, I'M GOING TO TAKE A *LOT OF DRUGS* AND GO *BOWLING!!*

OMAHA?? THIS FLIGHT IS BOUND FOR *HONG KONG!!*

HONK KONK?? THAT'S EVEN *BETTER!!*

PILLOW, SIR??

PSSST!! CORPORAL, I'D LIKE TO *BUY* A COUPLE OF *BOWLING BALLS* BEFORE WE *LAND!!*

ZIPPY DOZES OFF FOR MOST OF THE FLIGHT--

SIR?? WE'VE ARRIVED IN *HONG KONG*, SIR!!

A *SKYJACK*, HUH??

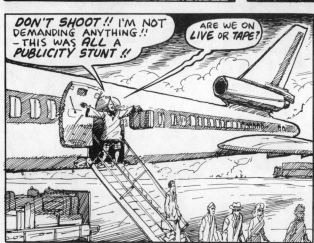

DON'T SHOOT!! I'M NOT DEMANDING ANYTHING!! --THIS WAS *ALL* A *PUBLICITY STUNT!!*

ARE WE ON *LIVE* OR *TAPE?*

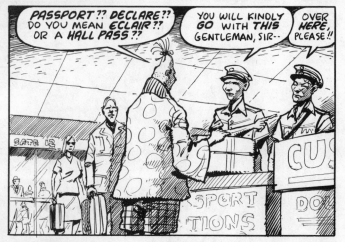

PASSPORT?? DECLARE?? DO YOU MEAN *ECLAIR??* OR A *HALL PASS??*

YOU WILL KINDLY *GO* WITH *THIS* GENTLEMAN, SIR--

OVER HERE, PLEASE!!

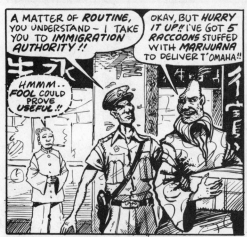

A MATTER OF *ROUTINE*, YOU UNDERSTAND -- I TAKE YOU TO *IMMIGRATION AUTHORITY!!*

OKAY, BUT *HURRY IT UP!!* I'VE GOT *5 RACCOONS* STUFFED WITH *MARIJUANA* TO DELIVER T'OMAHA!!

HMMM.. FOOL COULD PROVE *USEFUL!!*

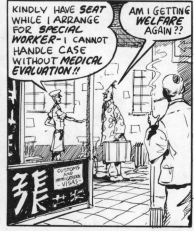

KINDLY HAVE *SEAT* WHILE I ARRANGE FOR *SPECIAL WORKER* - I CANNOT *HANDLE CASE* WITHOUT *MEDICAL EVALUATION!!*

AM I GETTING *WELFARE* AGAIN??

CUSTOMS AND IMMIGRATION VISAS

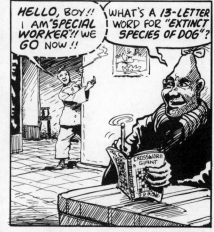

HELLO, BOY!! I AM *"SPECIAL WORKER!!"* WE *GO* NOW!!

WHAT'S A *13-LETTER* WORD FOR "*EXTINCT SPECIES OF DOG*"?

CROSSWORD GIANT

YOW!!

FOLLOW ME!! RUN MUCH *FAST!!*

UP STREET!! NO STOP!!

PUFF!!

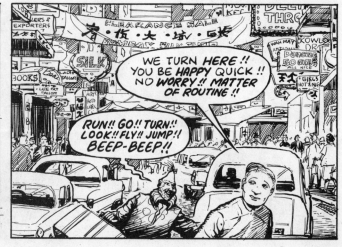

WE TURN *HERE!!* YOU BE *HAPPY QUICK!!* NO *WORRY!!* MATTER OF *ROUTINE!!*

RUN!! GO!! TURN!! LOOK!! FLY!! JUMP!! BEEP-BEEP!!

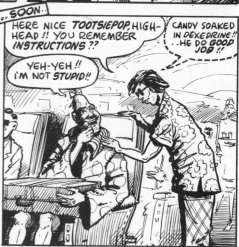

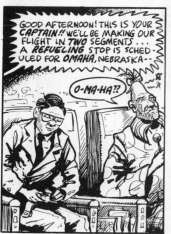

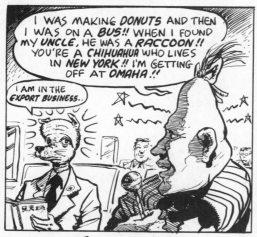

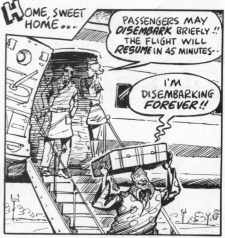

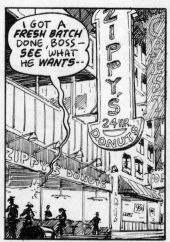

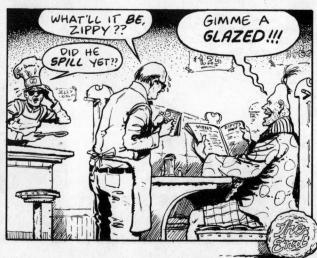

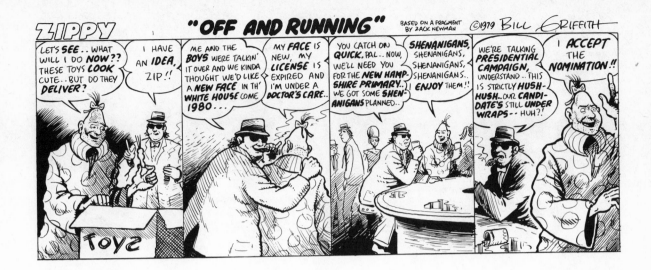

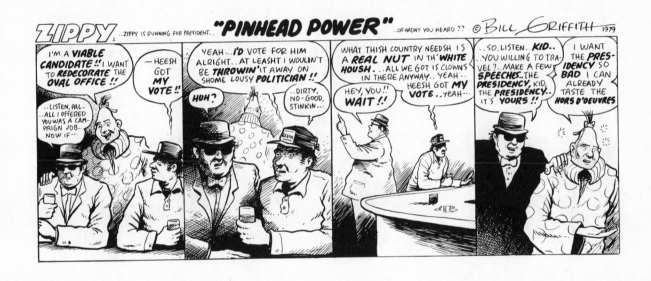

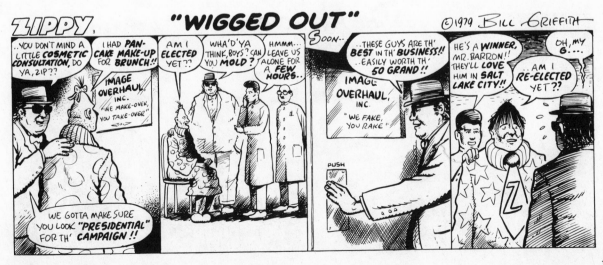

135

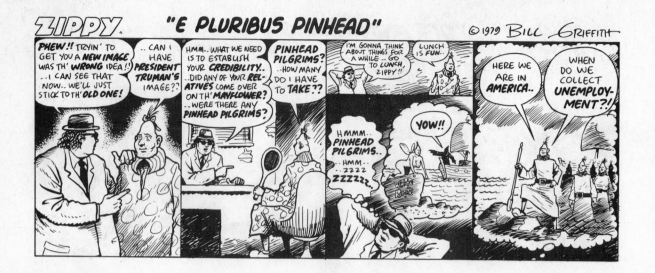

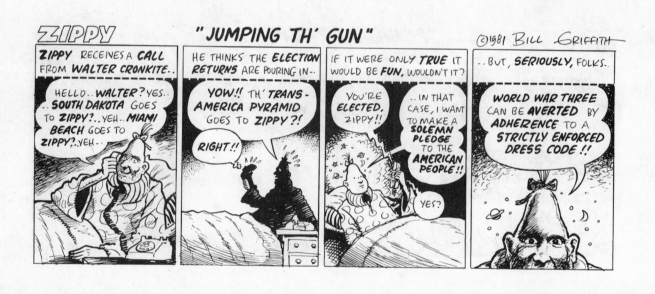

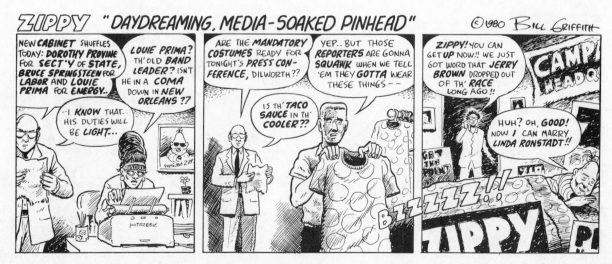

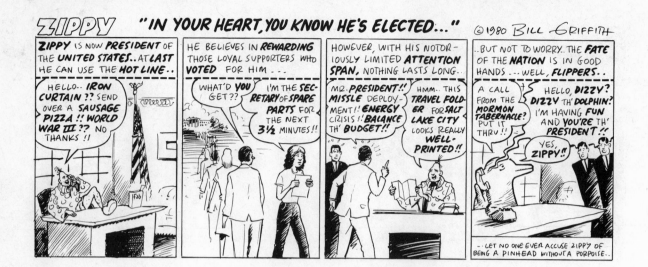

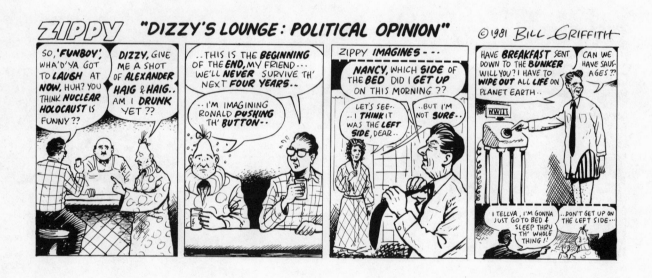

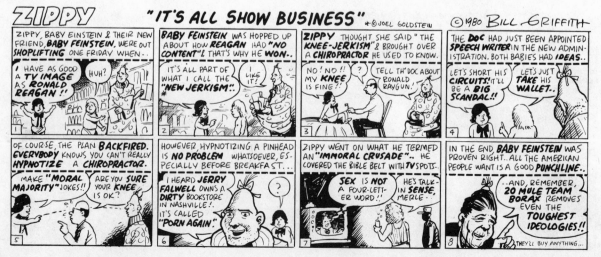

ZIPPY "ADULT LIVING" ©1981 BILL GRIFFITH

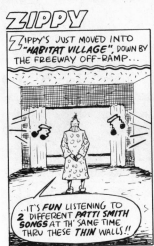
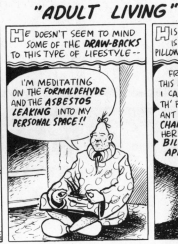
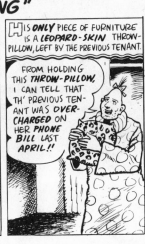
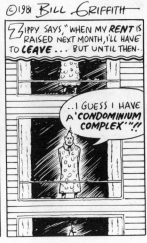

ZIPPY "LIFE IS TOUGH" ©1980 BILL GRIFFITH

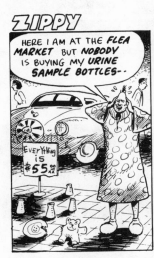
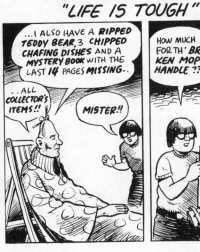
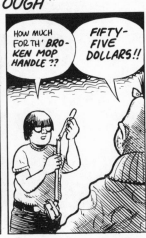
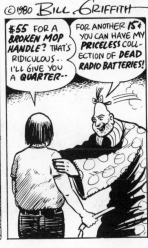

ZIPPY "MEDIA EVENT" ©1980 BILL GRIFFITH

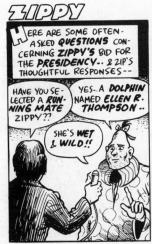
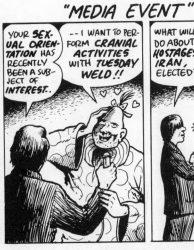
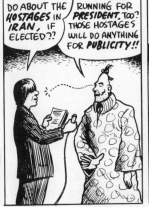
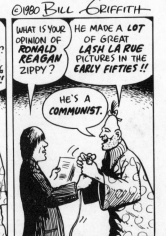

ZIPPYVISION

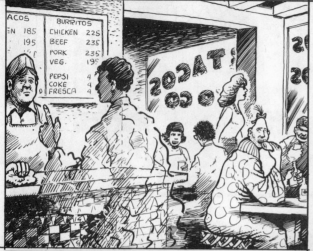

Zippy sees the Spirit Body of Eddie Fisher ordering a chicken taco.

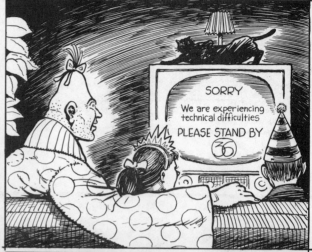

Zippy finally decides to go into show business.

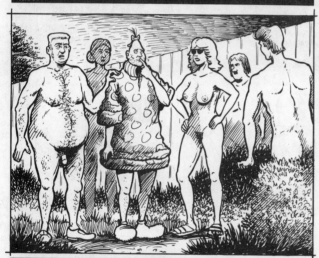

Zippy fails to understand the concept of the nudist colony.

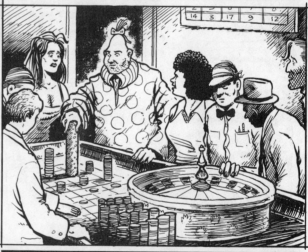

Zippy puts a Polish Sausage on sixteen red.

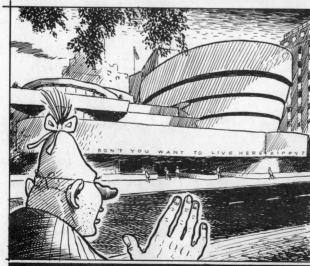

Zippy must have the Solomon R. Guggenheim Museum.

Zippy is depressed.

140

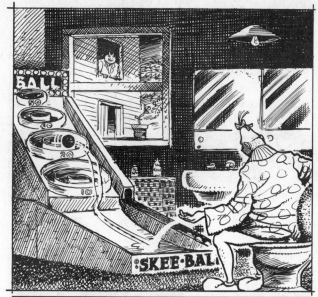

Zippy installs a Skee-Ball lane in his bathroom.

Zippy discovers he can levitate after drinking eleven bottles of Pagan Pink.

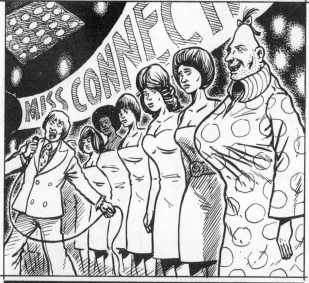

Zippy thinks he is a runner-up in the Miss Connecticut Beauty Pageant.

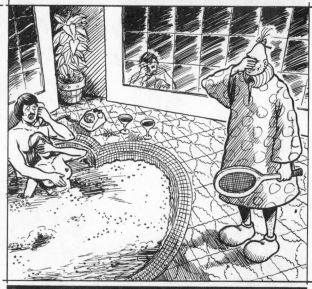

Zippy mistakenly enters the Bridal Chalet at Honeymoon Haven Resort.

Zippy goes for the gusto.

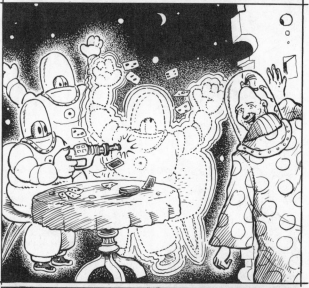

Zippy is overjoyed when he realizes alien beings cheat at Canasta.

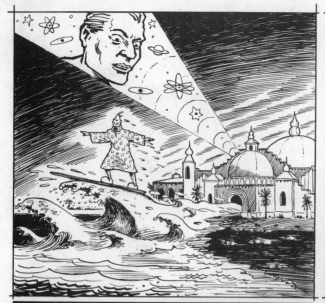

Zippy accidentally floods Rosicrucian Headquarters.

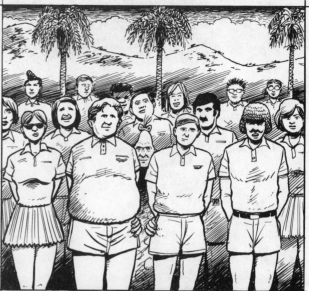

Zippy ruins the group portrait of the Beverly Hills Tennis Clinic.

Zippy wakes up in the middle of the night and swallows his earplug.

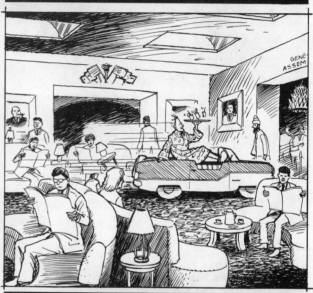

Zippy careens through the United Nations Delegate Lounge in his 1958 Rambler Metropolitan.

Zippy legally changes his name to Joseph Bambrick.

Zippy is elected President of the United States of America.

end

"ED BABAR FAN CLUB MEETING"

© 1978 BILL GRIFFITH

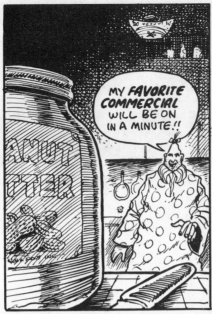

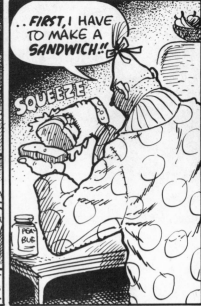

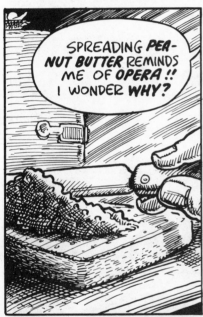

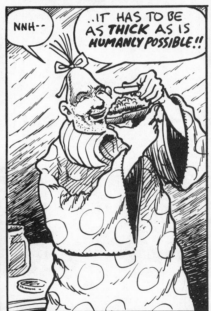

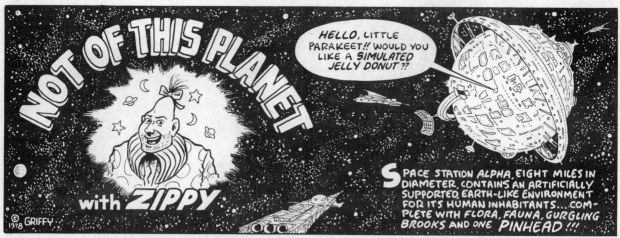

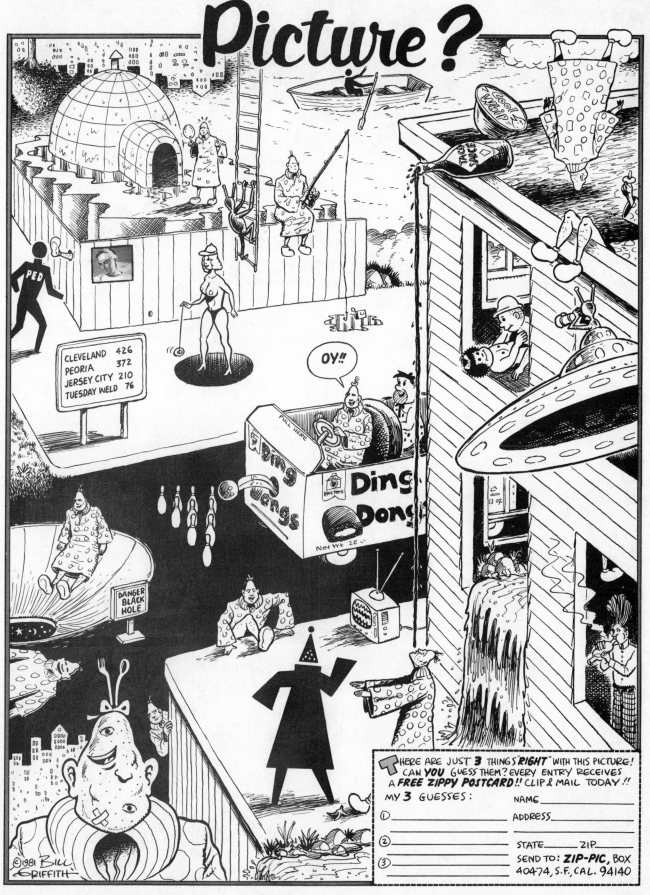

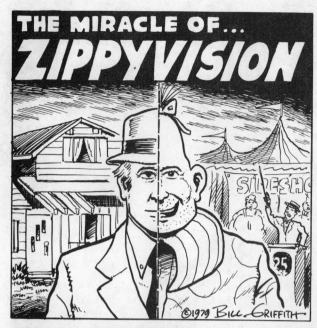

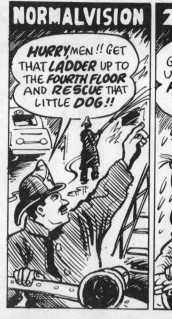

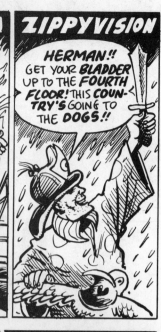

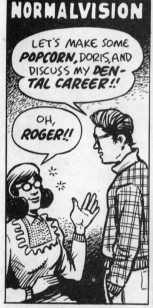

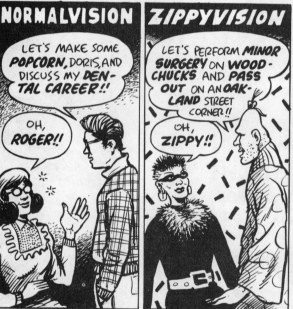

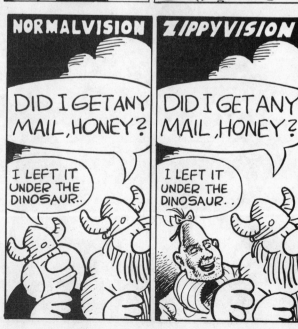

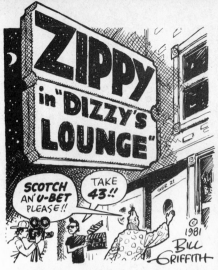

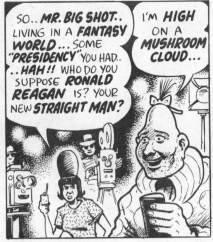

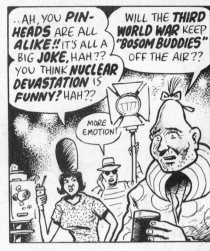

147

ZIPPYISMS

Zippy travels back in time to mid-fourteenth century Paris. It's lunch time and he has a terrific craving for a grilled cheese on white. As he wanders through a crowded back alley looking for a Howard Johnson's, three gallons of rancid cabbage soup issue from a second story window and drench him from head to foot. Five minutes later, he slips on a pile of irridescent green toreador pants and lands in Modesto, California, just outside the Rexall drugstore.

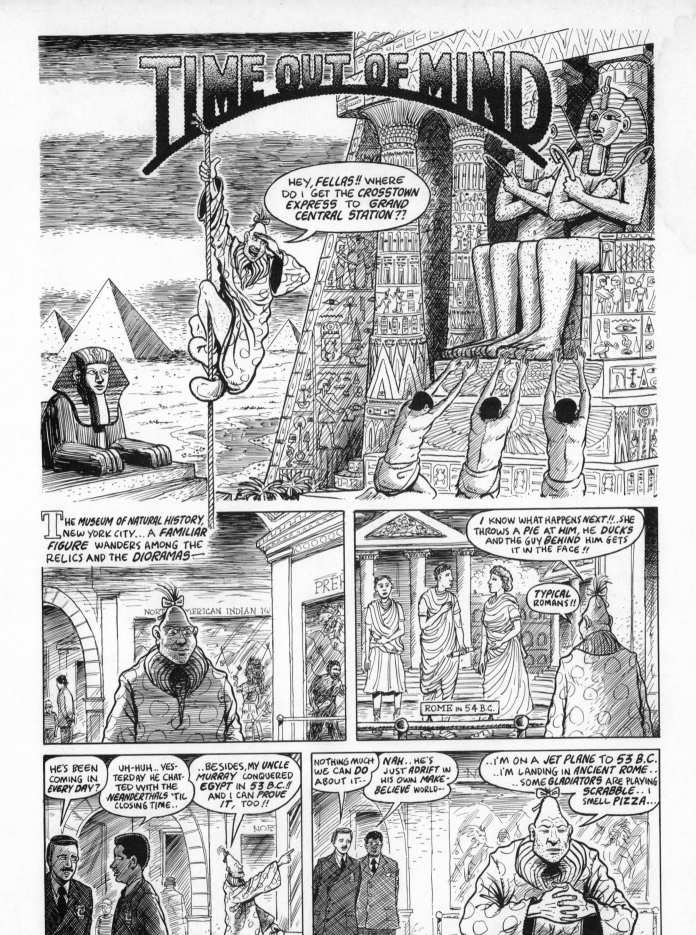

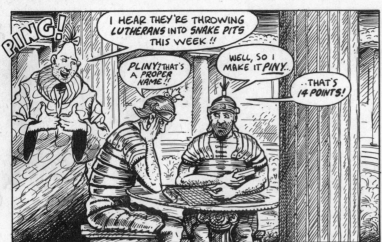

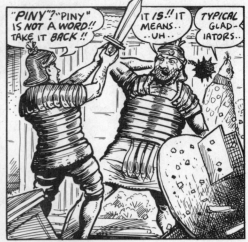

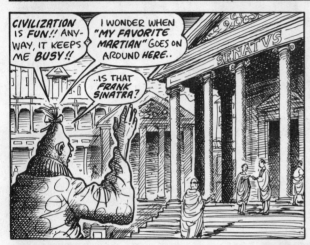

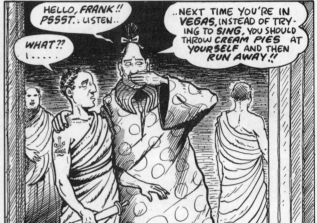

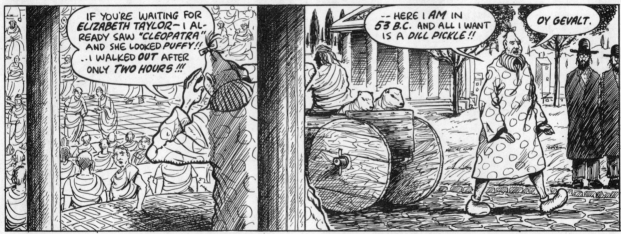

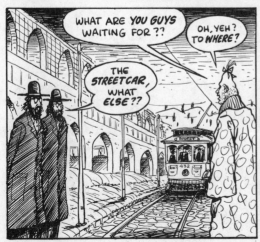

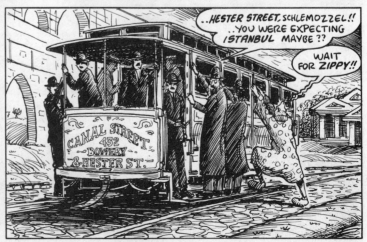

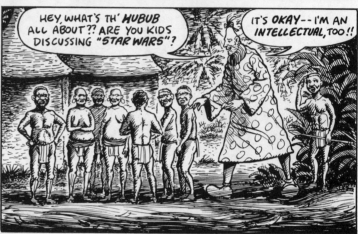

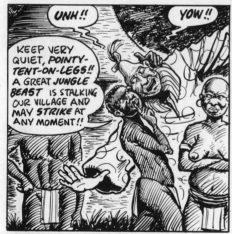

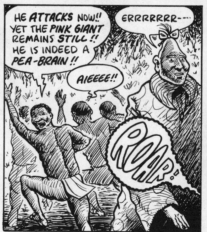

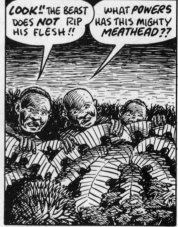

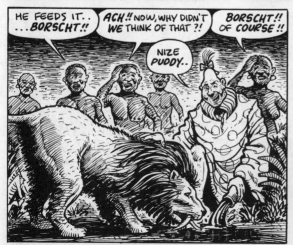

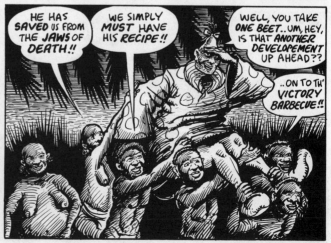

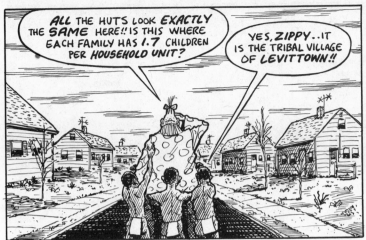

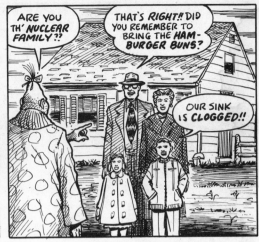

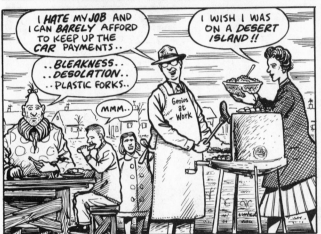

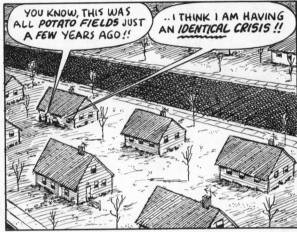

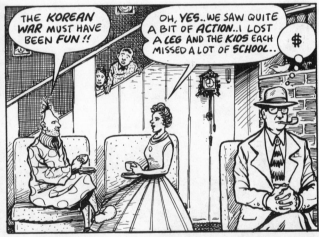

END.